GATHERING

Homepsun Essays from Beech Tree Lane

GATHERING
Copyright © 2019 by Dianne Poston Owens

Distributed by Bublish, Inc.

Paperback ISBN: 978-1-950282-81-4
Digital ISBN: 978-1-950282-82-1

www.dianneinhannah.com

GATHERING

*Homepsun Essays
from Beech Tree Lane*

DIANNE POSTON OWENS

For those I've met along the way, who have become a part of my journey, journals and stories, and to those I've yet to meet who will add to future missives.

Toujours en avant … Always forward!

Introduction

I have journaled my way through life, with pen and paper in hand or keyboard at my fingertips. From my eyes and ears, and from their friends, smell, touch and taste, crazy synapses inside my cranium conjure words, and out they flow.

I come from a long line of journal-ers, or journalists, as I have been. One of the first of note in my lineage is William Bartell who, with a flourish of his quill, wrote "William Bartell and Senea Stone his wife was married the 3rd of August in the year of our Lord 1820."

I am a slow-life chronicler, an observer trying to make sense of the usual and routine. I live on the old family farm. I travel to small towns in rural South Carolina, meet people and tell their stories. I visit, but am not at home in, big cities.

I welcome you to my world of essays, musings, philosophizing, photos, thoughts and ponderings. Remember, these are my musings, my memories and my perspectives. If you know some of the people and places I've written about, you will have your musings on them, your memories and your perspectives. That's a good thing. None of us have a handle on the whole of a person or thing.

Use these words for inspiration, reflection, and remembering, on the way to living a more thoughtful life.

xoxoxo,
Dianne

Table of Contents

Introduction ...7

Hello from Beech Tree Lane11

Community ..14

Gleaning..17

Porch Living ..22

Do We Speak the Same English?25

Making Syrup ...29

Antique..32

Mr. Merlee...35

The Artist...38

Building Bridges, March 7-14, 1839...........................42

Beech Tree in Winter ...45

Self-Help ...48

Snail trail on sand ..54

The Giving Season..56

How Do You Remember? ..59

Dress for Success ...63

New Crops..66

I Share These Truths...69

Back Roads ..72

Competing Legacies..76

Playing Dress Up ..79

Be Free..83

Unintended Consequences...85

Answered Prayers ... 88
The Notebook Project ... 91
Get To It! ... 95
Eulalee.. 97
Sipping from a Saucer ... 100
Hey Cuz! .. 104
Encourage ... 107
Beech Trees in Summer .. 110
Be Ye Kind .. 113
A Place To Be ... 118
Say Yes .. 121
Apothecary.. 125
Diagnoses .. 127
Cultivating .. 131
What Do You See? ... 135
A Time to Sleep ... 138
The Starfish.. 142
God Loves Us ... 145
Top of the Raindrop ... 148
Didn't See It Coming... 151
Live Life Loosely.. 155
A NASCAR Education .. 158
Motivation .. 162
Tracks and Scat.. 166
Leave the Mess.. 169
Call Me When You Get Home 172
About the Author ... 174

Hello from Beech Tree Lane

Turn onto the half-mile, dirt drive and follow it to its logical conclusion. Beech Tree Lane. Let's go to the end, if you dare – the end of the road.

If you choose, don't take the last curve to the left so you end at the house at the edge of the woods. Park, step out into the tall grass, fade right under the beech trees, and merge with the woods where they enter the swamp.

From there, you can push off in the ever-ready canoe into the slough and meet the river. The Lynches, a river and its lakes, named years before our colonists could attempt to declare independence, is the original lane that connected the people.

Let's discuss the beeches that live among the pines, oaks and river birches. They are neighbors of the cypress. The beeches transcend the seasons and traverse the years. They are not the oldest tree in the woods, but they persevere, replicate and are among the tallest.

They bloom in spring, give shade in summer, offer fruit in the fall, and provide copper penny leaves on which to walk in winter. The lane ends at Beech Tree Landing, where the water pauses before moving on down and out to sea.

Beech Tree Lane brings you past the remnant of an older farmstead and a barn, right past the place in the road

where the old barn used to be, where the cows grazed and doves still congregate. Pass the fields that once produced corn, tobacco, beans and such. Beech Tree Lane takes you back, from the highway to the river ... from the fast to the slow.

The lane also takes you past my front porch, where – most days – folks are welcome to sit and rock. Some days I want to rock alone, no intruders. Today, I'm inviting you onto the porch. From here you will meet communities of people and places, and the community of nature through which you see the nature of community.

Let's sit a spell and see where our rocking takes us.

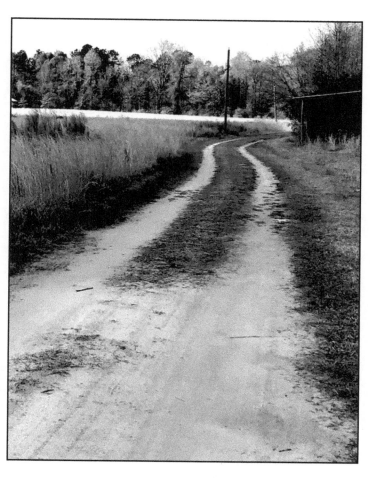

A portion of Beech Tree Lane

Community

We are the makers of subcultures. You and your friends who play bunco. The Monday morning sewing group. The "If it's Thursday, it's the Bistro" group. We create communities by the places we frequent (Barnes and Noble every Thursday morning that we're in town), and the ones we consciously join, (an American Revolutionary War reenactment group).

And there are subcultures in the subcultures. Once we join the book club, then we are part of either the group of five who enjoys movies or the group of four who enjoys trying out the recipes in the back of the cozy mystery books.

We are beekeepers and bookkeepers. We are members of associations and associates who mingle at the Chamber of Commerce event. There are the communities we are born into, families and schools, church and such, and the ones we are dragged into by well-meaning neighbors, such as homeowner groups.

To live is to be in community, find your tribe, meet with your peers. We give, we take. We flourish, we fade. We forgive and hurt others, requiring forgiveness. There is much to work out in our communities.

There are the "lesser knowns" in our communities, and we may be among them. There are the "better knowns"

that we watch from afar and to whom we hope to match our stride. Up. Down. Back. Forth. The rhythm of life, danced best when the dance floor is full and we can get lost in the community of dancers.

One-two-three … here we go …

Of all your communities, where are you happiest?

Where do you fit in the best?

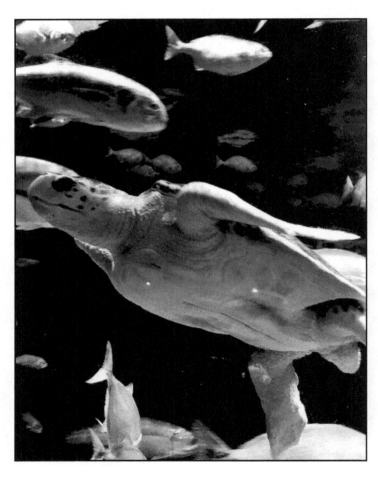

Happiness is making the most of where you find yourself
by exploring it anew each day.

Gleaning

My hearing was good, as my ears were working just fine, and I could type about ninety words a minute. With these skills, and in need of money, I accepted the chore of transcribing a young woman's oral interviews with elderly men and women in the community where she was raised. Though older than she, I was beyond thirty and not yet sixty. The woman was barely thirty and her friends were well beyond sixty.

I was ready and prepared to transcribe her interviews, verbatim. I wasn't prepared to enjoy listening to these conversations among and between friends, neighbors and family members. I became the eavesdropper, transported by their words to a seat on the window ledge looking in, listening through a screen, or perched on the arm of a sofa, leaning in, as it were, into the rooms with the interviewees.

To get the exact wording of each conversation translated exactly, I played the audios over and over until I captured their exact spoken words. I took to making notes about the giggles and laughter, the huffing and puffing, and wrote those notes about their inflections and tones in parentheses. I was mesmerized by these conversations.

It was hours, a few days that we were bound together. Their sing-song voices, some gentle and soft, some coarse and wounded, recounted their lives. Sisters played off one

another, joking and laughing, reliving free-flowing memories. The father figure encouraged the neighbor's daughter as he would his own.

They talked about getting an education – or the lack of it in a formal classroom – of their moves to northern states to get fair pay and opportunity, of their pursuits of bettering themselves, of their homes and land ownership, of raising grateful and ungrateful children, whether theirs by blood or someone else's.

My memories became mixed with their stories. Where was I the year she moved? Second grade ... the simultaneousness of life. While I lived over here, doing what it was I was doing, there were those over there, doing some of the very same things.

I bought groceries. I cooked a meal, the way my mom was taught by her mother. I watched television. I entertained a friend and offered a cup of tea. And others were, and are, in eerily similar ways and in vastly different ones, doing the same.

Simultaneously. We exist.

Some are seasoned travelers. Some are still learning to navigate the journey. A couple of these ladies, the oldest in their nineties, talked about doing whatever it took to do what had to be done to improve their circumstances, even when it meant leaving behind everything they loved, to work in jobs they truly didn't like until they could become who they wanted to be.

One chose to leave home and moved in with a relative for a while. The move involved tending to the children of a couple in a far more privileged circumstance than she found herself. While the pay was good, she quickly learned

that rearing other's children was not for her. She found herself, she said, when she moved to Pennsylvania and became a guard in a prison, a job newly opened to women. She was a trailblazer, not a babysitter.

When she came home, back to South Carolina, she was retired, self-assured and still no one's substitute mother. Others followed the successful paths of older brothers and sisters, cousins, kin.

Their stories reminded me of a woman in the Bible named Ruth. Wherever you go I'll go, she told her mother in law. Women often stick together. And Naomi sent Ruth to glean. In a wheat field, I believe. Gleaning led to bringing in the sheaves.

Funny word sheaves. Funny word, too, "gleaning." The two, in my mind, are linked together. I see myself bringing in the sheaves, little bundles of grain tied together with twine. That's what transcribing these conversations did for me. They allowed me to glean a field.

Take the leftovers. Someone else planted. Someone else watered and tended the crop in the field and then came the harvest. In a sort of cleaning up before another planting, I gleaned. Gleaning from the lives in their stories reminded me of the Ruth story.

And I came to understand that in reality, a person can still, to this very day, glean a field. It's not an archaic thing to do. I can plant a field of sunflowers in such a way as to gather what I want, and leave some for the others. Gleaning is not just an Old Testament memory. It happened. It happens. Yesterday. Today.

Anything grown can be harvested and gleaned. I gained new insights, new realizations, by gleaning from

these conversations. I bring sheaves of their memories into my world; bundles of fruits tied together to feast on in the future.

We are forever linked because they spoke and I heard. We have always been in this thing together.

What do people glean from you?

When was the last time you eavesdropped for the pleasure of it?

Someone is always watching, and if they are watching,
They are listening.

A face of nature, Georgetown, S.C.

Porch Living

In my world, rocking chairs and dragon flies co-exist. I have a porch that's plum full of calm and composed, well-weathered wooden rockers sitting at the ready for guests.

We are all in this thing together. Butterflies and bees, hummingbirds and wasps, snakes and moles and other creepy crawly things.

Things I don't treasure live with those things I do. We co-exist. I am tolerated.

Live and let live. Rest and let fly.

In late spring, the dragon flies come in droves and spend the summer with their friends on the rockers on the porch of the house on Beech Tree Lane. They strike that certain pose, these dragon flies of all shapes, sizes and giddiness, mostly on the backs and arms of the chairs, but occasionally they'll take a seat.

I am sometimes in the rocking chair, waiting, watching, like the beech tree, for something to happen, someone to come along, something to be done. Again, another time, I envy the dragon fly, flitting from chair to chair, out beyond the porch and back again.

To the Ecclesiastes' Chapter 3 list, I add "There's a time for sitting and rocking and there's a time for flying."

Gathering

Where do you enjoy resting?

What are you busy doing that you should not be doing?

What do you wish you had time to do?

Rocking chairs and dragon flies, at home.

We are all in this together.

Do We Speak the Same English?

It's no secret. I'm always listening to folks. Older people don't care what people think of what they say and younger ones don't know enough to care what people think.

Those of us stuck in the middle of old and young, however, are required by statutes and ordinances to watch what we say, how we say it and when we say it. We also have to work to ensure that what we're saying is what is heard and then, we hope, understood.

Warning: Speaking something to someone may not lead to that someone understanding that something. Our words can confuse.

Once upon a time my oldest daughter, a second grader, and my youngest, a first grader, were conversing about their prospects of getting married and leaving home. Not only were they figuring out who would marry first and how far away they'd move, they were also discussing who would be stuck taking care of dear old mom and dad.

My oldest quite matter-of-factly announced she was not really planning on marrying. As she put it "I figure I'll stay single file the rest of my life!" She didn't, as a matter of fact, stay "single file." Like many, she learned to dance "two by two." But in her second grade world there was a lot of "single filing" going on. She couldn't imagine life in any other form.

Once upon another time my great-aunt Gladys and great-uncle Bill, totally British and hailing from Woodford Bridge, Essex, visited. At the end of one day Aunt Gladys was recounting her adventures of seeing three dead deer following a hunt. The deer lay wide-eyed and ready for dressing (or undressing as it were), heaped into the back of a pick-up truck.

"... and he said he was going to mount the head of one of them," my aunt said.

Horrified, my younger daughter looked at me and asked, "How are they going to melt it?

In a world where "mount" and "melt" can be mixed up in the distance from tongue to ear, stories can be misconstrued and meanings lost.

After a lot of laughter while listening to my aunt repeat, and practice saying the word "mount" in a more Americanized way, she gave up. Instead, she said "I believe he plans to take the deer's head off the body and clean it up in such a way that he can hang it like a picture on the wall."

Though wordier, her meaning was much clearer. My daughter was no less horrified.

I once heard myself say to my children who were jumping from sofa to chair to floor in the next room, in that loud mom's voice that we inherit and startles even us, "Don't you ever let me catch you doing that again."

Really? Don't let me catch you?

Uh-oh! Sounded to me as if I was giving them full permission to jump as much as they wanted, as long as I was not around to catch them.

I rounded the corner and saw the gleam in their eyes. They understood that precise meaning of those words as well.

I said, "Let me rephrase that. Do not ever think about jumping on the furniture, off the furniture, from the furniture or between the furniture in this room again!"

There! Nice, specific, and easily understandable. Or so I thought. With words, there are almost always loopholes.

It wasn't five minutes later, likely after some discussion of what constitutes furniture, that I heard their snickering and discovered them jumping on a bed. Okay then. More furniture, different room.

And the problem with "okay" is ... well, it's not okay in every situation, is it?

Okay is a word that needs defining before you use it, or you will have misunderstandings. Is "okay" the same as saying "Yes!" It's fine!" Or is "okay" a disguise for "No way!"?

"That dress is 'okay' ..." Well then, should I wear it or take it off?

We may all speak English in my neck of the woods, and maybe in yours, but I'm not all that certain we understand one another.

When did a misunderstanding lead to a better understanding?

What words have you noticed that cause confusion in your life?

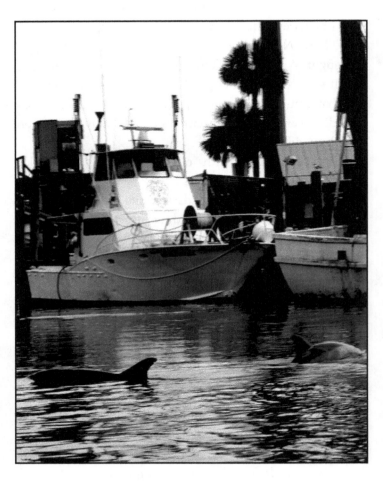

You go your way, I'll go mine and
we will see one another after a while.

We are together and separate, alone and attached.
Those are each good places to be.

Making Syrup

I once met this guy who felt it was important to keep doing what he had seen his wife's grandparents do, make syrup from cane. Sugarcane, grown on his property and on others, was loaded by hand onto a wooden wagon and pulled by a nearly modern tractor to the mill house.

The cane was placed into one end of a hand-cranked mill, and squeezed until the juice flowed out into a fifty-gallon barrel. There is a ten-gallon to one-gallon ration of cane juice to syrup, the farmer said. The juice is processed, through boiling and cooking, and reduced to its essence.

The essence of the cane grown in the field is syrup. From a solid to a liquid.

While the cane is cooking, it is skimmed. "There's a lot of skimming," he said. Some things ought not to go into the syrup.

The juicing, boiling, cooking and skimming take about eight hours. Then comes the blending, the process of combining the cooked and skimmed syrup into pressurized tubing into the bottling pot. From field to finished product, it's a solid day's hard work. And it's a solid day's work for several people. Working together, each in tandem, allows the process of syrup-making to be accomplished, start to finish. Raw to refined.

Sugarcane, in its natural form, just so you know, can be chewed on, but should not be swallowed. It is a fibrous,

woody plant that gives way under pressure and processing to become something much sweeter and enjoyable. Like much in life, sugarcane's best use comes after the tough stuff, after the squeezing, the high temperatures and time, after the boiling and before the bottling.

Much in life is meant to be chewed and spit out, just saying. We need to watch others and learn from them, or we could swallow what we shouldn't. From observation and experience, again, just so you know, sugarcane syrup is best enjoyed in combination with something else, like a pancake or a biscuit.

We are all pre-salsa, pre-biscuits, pre-syrup. We are ingredients ready for the process. And after our process, then, perhaps, we are all the more enjoyable.

When have you felt like you've been squeezed, boiled and skimmed?

What are you becoming?

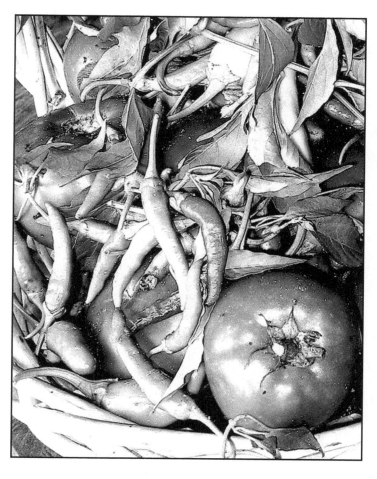

Home grown.

It's all pre-salsa.
We're always in process of becoming something else.

31

Antique

I am the keeper of many old things.

The bushel-deep corn box with the mechanism that once stripped kernel from the cob. It still works. If it was needed. But it's not. I turn the handle occasionally and imagine what was. New tools replace it. Combines and such.

This contraption handled one ear at a time, mostly for the chickens and cows.

Time has passed it by. So it sits on my porch.

I am the keeper of the recipes and the small, silver suitcase in which they were found.

I have a ten-dollar confederate bill, framed with the receipt proving my great-great-granddaddy paid his Confederate War tax. November 25, 1863. Three dollars, twenty-nine cents. This time, we obeyed the law.

I have glass bottles with corks. I have jugs.

I have old cameras that took pictures of things that are no longer here.

That's the way it goes. Dynamic, living world.

I am the keeper of old furniture and dishes, old pictures and a scrapbook that was my grandmother's that dates to before the 1920's. A 100-year-old scrapbook.

Some things don't need digitizing. Some things need holding and touching.

I have an old hand mirror for primping in and old handkerchiefs for the sniffles. Old tackle boxes and lures. Old teeth, fossilized sharks' teeth.

I am the keeper of many more old things.

One day, someone will say out with the old and in with the new.

I have old typewriters and new laptops.

I have Wi-Fi and communicate untethered, wirelessly.

I am guilty of pushing out the old for the new.

What is your favorite new technology?

What did it replace?

What would it take to do without it?

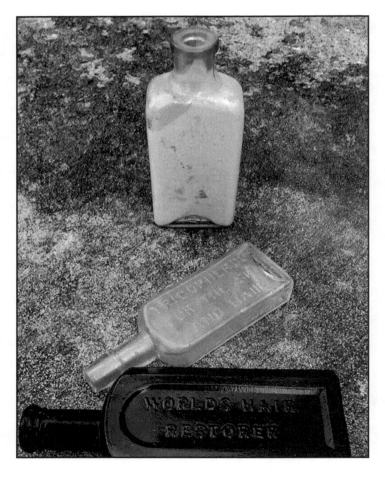

Restorer in a bottle.

For old skin and hair.

Mr. Merlee

The most humble man I ever met walked barefoot in summer and wore Brogans in winter. But he walked. I don't know if he could or couldn't drive. I just know he walked. He was not bothered by the maintenance of a vehicle. I'm not sure if his world was small and he saw no need to venture far, or he simply didn't have the money to invest in a vehicle.

He got to the little plank-wood church before everyone else to set the heaters in winter and to open the windows in summer. If it rained as he walked, others stopped to take him along to wherever he, or they, were going.

After fishing, he always shared his catch. His wife's name was Mabel. I don't know if they had children. It was just the two of them in their square house by the road by the time I remember them.

Their house was dismantled board by board by people and time long after they left us. I don't know where the boards went.

He stood like a pine and spoke with a hush. He was present and pleasant. Kind. Mabel was shorter and her laughter louder.

If there was a fish fry, or a fish stew, Mr. Merlee had something to do with it.

It's been years since his death, decades even. At some point it'll be a half-a-century, then a hundred years. He is gone. She is gone and their house is gone. Pines trees grow where their home once stood.

Gone and forgotten?

Gone but not forgotten?

I can barely see him now, a shadow of my younger days, walking in the edges of my mind.

Who has made an impact on your life because he or she was important to the community?

What person do you remember from your childhood as being important and unforgettable in the community?

Dogwood Village in Spring

It takes a village … go create yours and then go enjoy it.

The Artist

From New York to Nesmith beside the railroads in the woods in Williamsburg County in South Carolina, and to points beyond, she has traveled. I met a woman who paints stories with pieces of fabric and weaves art with thread and heart.

She's a quilter from a long line of quilters and she shares her hurts, tears, celebrations and joys in bright browns, strong blues, hues of purple, pink, and orange. Black and white are ever present, but oh so unnecessary. The colors take front and center stage to ovation after ovation.

This one? It is her grandmother the guardian angel, afloat, heaven bound. This one is freedom, pure and delightful, with happy feet and well-dressed smiles. The cowrie seashell, a favorite of hers, brings wealth and treasure to each scene, stitched by bleeding fingers and tired, achy hands filled with joy and love.

She is an artist, painting with her quilts, the stories she knows. We tell stories through pictures long before we use words. Our story. Collective. Together.

There is laughter at the edge of this strong woman's mouth, a queen for all people. Us. We.

When the artist talks about a piece that took three years to compose, because she kept remembering there

were more faces and hands and feet to add to the collage, it is then her teary eyes shine like the angel on top of the Christmas tree. She loves. She remembers. She quilts.

This chocolate-caramel woman sees visions. She is awakened by music and words, she says, in the dead of night. Our songs. From Africa to America and back again. From Shanghai to California and back again. The created.

She paints with thread and fabric, the delicious tales of women who die too young from cancer, of men who need to break free.

Born in New York, she came to be raised by a quilt-maker who covered her family in love and laughter and song and dance. Quilters who begat quilters. She learned well in this crossroads community with railroad tracks, trees and grapes.

No thimble protects her fingers. She yearns to feel the silk, the linen, the cotton, and wool. Hand to fabric. She caresses the stitches and threads that are the story of her love for family, of that time they took a day trip to the beach.

There are hands that lift up, hands that hold; hands are often the heart of her handiwork. I sat amazed, eyes wide, listening to her. So at home with her art hanging on the wall. She feels so deeply and is so easily moved to create and make and do and recreate and remake and undo.

Her grandmother's house dresses always had safety pins, she says, and so does this quilt –

right here. See? They were always at the ready to keep it together. The grandmother and the pin.

There is a whole lot of Jesus in her art. There is a whole lot of soul. There is a piece of self-expression with

threaded words written onto cloth and a young woman with a microphone. She is affirming, loving, classy, independent, caring. She is self-affirming. She affirms us all.

There is finished work she sells. There is finished art she shares and packs up and hauls back home. There are the unfinished pieces she carries with her in her bag.

This woman, so old and so young, timeless and beautiful, is a work of art.

She created a purple sky with dove and sun; blue water and golden sand. In this story, there is a woman robed in white, dark cocoa-faced, at peace. This is my favorite story to see on the wall.

She will not part with it. It is her best-spun yarn as well, the woman at peace.

The artist touches us with her stories painted with pieces of fabric and reflects about those who came before her, who also quilted stories, and of those who surround her now. There will be those who will come after her.

She is they. We are them.

What are you representative of?

What art do you create?

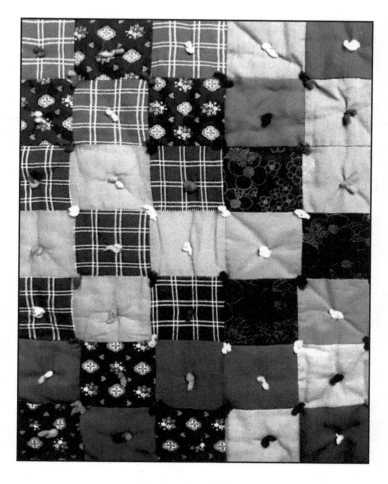

Patchwork and pieces

That is all we are.
Out of the many comes the one.
So comforting that it works.

41

Building Bridges, March 7-14, 1839

"Was at home and was dressing head and foot board of bedstead ... rain." Such is this entry of an ancestor's journal. I believe dressing is adding a coat of shellac or such, but it could mean something different, entirely. Words' meanings change over time.

"Was at home in the morning and then went to steel traps June Island. Was at home and then went to muster William Stone's ... was at home then hauled planks for bridge ... was hauling planks from Bosticks for W.H. Stone to put on the bridge. Was at home in the morning and then went down to Georgetown."

William Bartell stayed in Georgetown two more days before he wrote, on March 17, "was in Georgetown and then home."

That trip from "home," somewhere along the Lynches River in today's Florence County, South Carolina, is some 45 miles away from Georgetown. It is likely his trip was to get provisions and was made in a flat bottom boat that navigated the Great Pee Dee River. He could have incorporated a little visiting into his journeying. He doesn't say.

Bridges were few in a swampy land. His weather, this week, was cloudy, fair and rainy. His work was arduous.

More bridges needed building. To get to the plank stage there is first a tree. Then the tree is cut down and

boards are hewn – grueling work, done in rain, on a fair day, sometimes with clouds. Day after day you work the wood until a plank is born. And then you haul it off. It's a gift you've made to be put to work as a bridge. For yourself. For others.

It is what they did. They cut timber and built bridges and dressed bedsteads. These ancestors were skilled at being and doing. Helping one another, taking care of themselves.

William took the time to record a note each day about his life. Because he put ink on paper, we know what he did, where he went, what the weather was like. We know his friends, when they married and when they died. He recorded facts. I search for feelings among his words. If they are there, I do not find them. Feelings do not matter when you are building bridges; doing matters.

What is *is* what is.

Though the actual journals were lost in some fire along their journey to the here and now, the words have not been lost. Someone transcribed them. Someone along the way copied the pages and those pages are now preserved as PDF documents, shared on computers that William's words, his ink and paper, could not have imagined.

"Was at home and … "

What are you working on that helps those around you?

What do you enjoy that others have put in place for you?

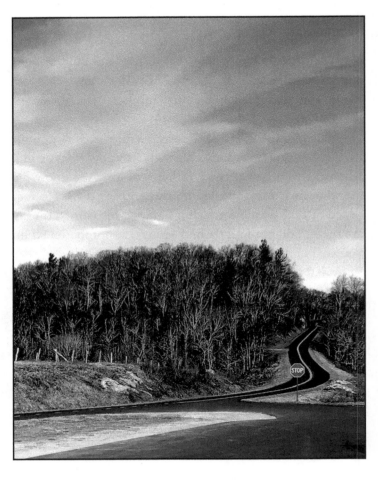

There is always someone to come before
who builds what is and will be.

Build well.

44

Beech Tree in Winter

Daniel Boone carved "D. Boone Cilled A Bar On Tree In Year 1760" into a beech tree on an old stage road in Tennessee. That tree returned to the good earth in 1916 when it fell. It was measured to have a girth of twenty-eight-and-a-half feet. The Forest Service estimated the tree's age to be 365 years, making it two centuries old before Daniel recorded his feat.

That's why I love beech trees. They stand tall, are well-rooted, hang out for a desperately long time, and allow us to carve our stories into their bark.

Beech trees are common where I live. As they grow, their limbs become wide open arms that spread wide a canopy that shields out the sun in the summer. They green slowly in the spring, and their leaves color themselves a beautiful penny-brown each fall. Those copper leaves that fall to the ground during winter cloak the earth below, staining it brown. The smooth bark is white with black, the perfect winter wardrobe.

Not a fast grower, the American beech is a legacy for future generations, sometimes topping six stories tall. What it lacks in speed, it makes up for in longevity. Its nuts are food for wild turkeys and foxes; its arms are home to squirrels and birds, and such.

Often found together in groves or clusters of three or four, the beech was a sign of fertile soil to early American

settlers, a foretelling of prosperity, though it was often removed so the plow could make way for food and clothing.

In 1863 James F. Creel carved just that into a beech tree on a bluff in South Carolina. A boundary tree most likely. Had he followed another's lead?

There's a smiley face, a person walking and more carved into the bark, all arm height from the ground, all around the trunk. Someone along the way denoted 1936, or 1938 – it's hard to make it out for sure.

In the 1960s, lovers carved their initials into the tree. D.L.P. added his name to the tree and so on, right up to 2018.

This tree, the family carving tree is in the winter of its life. The sapling that once sprang forth of its own initiative on the bluff at the edge of the swamp has been increasingly injured by winds strong enough to twist and break its arms, by lightning that shocked its core, and by time that depleted the soil.

The rain-soaked earth is too weak to hold the carving tree up. It will come down.

Beech trees in winter have stories. They've seen things. Felt things. They stand tall until they can't anymore. They are well-rooted until the earth gives up.

They hang out for a desperately long time until time turns its back on them and says "enough." And they allow us to carve our stories into their bark.

What stories do you leave behind for others to read?

Where is your gathering place where stories are retold?

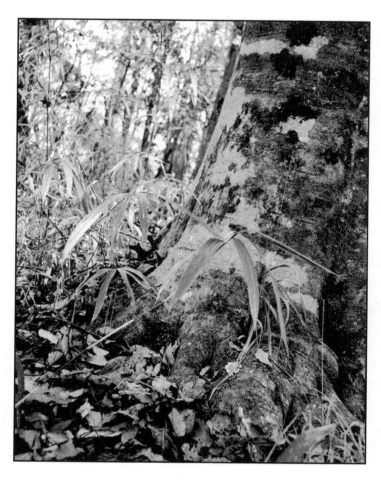

Beech Tree in Winter

Resting, quasi-awake, still aware and making ready.
Solid footing: A beech tree believes in renewal.

Self-Help

Sometimes I know I bring it on myself -- frustration that is. Sometimes, really, though, it has to be someone else's fault.

How do you handle it when things don't go your way and you're made to follow someone else's rules? Hand on the Bible, hand over heart, this is mostly a true story. Now, I laugh remembering it; then, not so much.

Once upon a time, back in the day, I, my husband, our nine-month-old and twenty-three-month-old lived in military quarters in Fort Stewart, Georgia. By day, my husband would train troops and keep America safe, and I would tend the home front. By night, we pretty much did the same.

Then came the day the window shade tore. And I needed to get a new one.

Living in government quarters was new to me and all I wanted was a window shade. I packed up the children and headed for the hardware store downtown. This was actually pre-Wal-Mart days. (I am a survivor of a pre-Wal-mart world. Many don't know what that means, so that'll be another tale for another time. Back to the window shade.)

I arrived at the local Hinesville hardware store, unpacked the babies, and muddled through the doorway, with window shade in hand. I was met by the surly store

manager. From his hair cut and demeanor I knew he was prior military. He practically turned me around as I came into the store.

"We don't have those here," he said, pointing to the shade.

"Oh. Ok. Where do they have them?" I asked naively, thinking I'm not up for a run to Savannah. I just want a window shade. One that works. One that isn't torn.

"Our shades don't fit post housing."

"Oh."

"Go back to the post," he said. "Didn't you get a self-help card?"

Oh. Yeah. Post quarters. Housing. I do remember being given a business card kind of thing when we moved onto post. As if reading my thoughts, the man said "If you live in government-provided quarters, window shades belong to them. Their replacement is their responsibility. And you have to go through the right procedures to get one."

Procedures. Rules. Regulations. That was where I always went astray. I was sort of an independent cuss, hated standing in lines, not good at following directions.

"Store bought shades won't fit those windows," he continued, telling me more about the construction of military housing and contractors and non-standard specifications than I ever wanted to know.

"You just go to the 'self-help' store," he said, making it sound so easy.

Just "help yourself." I was desperately trying. He gave me directions.

In theory, the self-help store on post was where they had what a person living on post needed, on a shelf, ready

to be picked up and installed by the person needing it. Sort of like a small-scale Wal-mart, I now realize. Sounds simple enough, and while I'm not good with following the rules, I am great with simplicity.

So, I pack up the babies and take my shade and prepare to make a quick jaunt over to the self-help office to help myself to a new rolling window shade. I arrived at my destination. I rummaged around in my wallet and found my trusty self-help card and military ID.

My mistake: I didn't call the office before driving over to it. So, though I had my card that said, "Yes! The holder of this is one of hundreds living on this post and entitled to self-help for household needs," I was denied entry until the office opened at noon.

I clearly heard "Lack of prior planning on your part does not constitute an emergency on my part." Of course I'm early. The office doesn't open until noon. No one but me, I supposed, would want a window shade before noon.

I returned home, unpacked everyone and got back to tending to the home front. At one o'clock, on the dot, hoping to avoid the noon rush of self-helpers, I headed out again.

"Yes. This is the window where you can get a window shade," said the man behind the glass shield. "Can I see your permission slip?"

"Permission slip? Here's my self-help card. Saying I'm entitled to self-help ... And here's the shade." I offered the man the torn shade. I wondered if the glass he is behind is bullet proof.

He stared back, unmoved.

For a second I thought he didn't understand my English. I was screaming inside "TAKE THIS SHADE AND ..." I completely understood his need for glass protection.

The children squirmed.

"Not without a permission slip from the post housing office saying 'Yes, this window shade is torn, and you really do live on post and are authorized a replacement shade. And you're authorized to use this self-help card to get a shade to replace the torn shade,'" could I get a shade, he said. My left eye began to twitch.

Self-help was not going to be easy, or simple. It was going to be time consuming and bureaucratic.

Huffing, puffing and ready to tear the whole house down, I gathered up the youngsters and set off to find the housing office, trying my best to follow this man's directions.

I arrived. I parked. I gathered us all up. I carried us all inside, where I was asked to sign in, so the proper authorities could keep a log of what it was people needed in their houses.

I didn't buy it. They tracked people coming in, as if they might ask for one too many window shades.

I was about to lose my mind when I was directed to the lady whose desk is in the middle of the room. We made eye contact.

She beckoned. I complied.

She said, when shown the window shade, and after looking it over, "Yep. This window shade is one of ours. Yep. It's torn. Here, just take this slip over to self-help and they'll be glad to help you..."

UGGGHHH!

But I was a fast learner.

When I locked myself out of my duplex a week and a half later, I went next door and called the housing office to

see where I should go to get help for myself. And what identification would get me the help I needed – in this case a key.

I was a needy person. I often required help to get me through the day back then. I left my children with the neighbor and went the mile and half to the housing office, to retrieve the loaner key that I signed out and promised to return.

As I walked out of the housing office, I was relieved. Nearly happy. Key in hand. It was then I was nearly trampled by a young mother, three children in tow, marching past me with a torn window shade. Hand to God.

Another trooper keeping the home front safe.

"We're in this together," I wanted to shout. Sure hope she had her permission slip.

Are you kind to others when they are frustrated?

When was the last time you helped someone out?

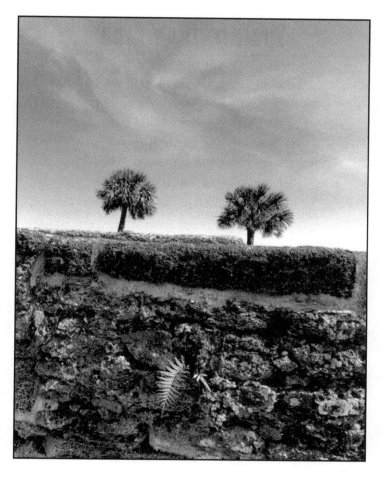

St. Augustine in summer

True story: I've broken my nose twice.
I'm still learning where not to stick it.

Snail trail on sand

Dear snail, thank you for the trail you leave,
Evidence of your travels.
You pack and carry your house and goods.
Your ears and eyes seek the way.
It's less important where you've been,
and more about where you end the day.

DPO

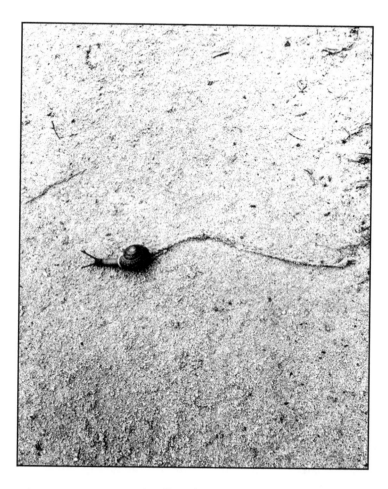

Snail trail on sand

The Giving Season

If you make it to the eve of Thanksgiving, you will say to yourself, "this year has flown by." And if you say that every year, then when Thanksgiving eve arrives, you better strap in. The next 32 days are indeed going to whiz by in a whirl. It is the nature of holidays.

The tiny little days that make up the weeks between Thanksgiving and Christmas are crammed with school plays and church cantatas, Christmas and holiday services, punch and fruitcake, office parties and get-togethers, shopping and gift-giving and gift-getting.

This is the season of giving.

We give our time, our money, our gratitude.

We give our hearts and smiles and tears.

We give our thoughts and prayers.

We give our appreciation.

We give and give and give again, to the Santa at the bell, to the charity that gets our ear, and twice to the angel on the tree and the empty stocking that gets our heart.

We search for the right gifts to give, not trusting they are ever "right" enough. I will re-gift. I am the conduit for gifts. Thank you for giving to me so I can give to others.

We cook, we clean, we work, and we help with the last-minute homework. I bake, I fuss, I grow tired and cranky and I laugh.

We take care of friends, parents and children. We go to church, make a run to the store, give, give, and give.

During these few weeks we need to also take.

We need to take deep breaths.

We need to take time to rest, nap and sleep.

We need to give thought to and create a plan for surviving what otherwise will overwhelm us – the busyness of the holidays. Our village will be overrun. We will be trampled. Our community runneth over.

But, if …

We give up on getting perfection …

We give up needing perfection …

We give up seeking to give perfection …

We might be able to sit back, ride this one out and enjoy.

Let's say "no" to things we don't really want to do and that bring us stress.

Let's say "yes" to things we really want to do.

Living with intent is the greatest gift we can give to ourselves and those around us.

Live the next few days with purpose and intent.

Enjoy the lights that brighten the days and nights between Thanksgiving and the New Year.

Practice the art of moderation, for it leads to contentment, enjoyment. Overindulgence leads to … well, not those things.

Be benevolent without extravagance. Give enough. And no more.

"Enough is a feast," the old proverb says.

What does enough look like?

Where do you share your more than?

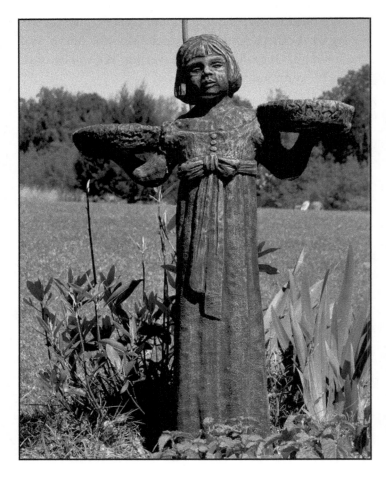

Find the balance.

Be yourself ... It is enough.

How Do You Remember?

Here it is, again, September 11th. A nondescript day that quickly became symbolic of madness, death, anger, profound sadness and the need to stand fast and move forward, out of our pain and into forgiveness.

It didn't begin on September 11, 2001. On that day, there was the culmination of plots and schemes against America and those who lived and worked here, regardless of their ethnic and cultural backgrounds. Tremendous destruction. Unforgettable video footage of wreckage and carnage. Audio of horrors.

This generation's Pearl Harbor. This nation's call to arms. It's been several years and millions of Homeland Security dollars since we were attacked. Terrorists. Those acts, that day, made us all who we are now. Where we are now, if not directly, then certainly indirectly, is related to that date.

On September 11, 2001, nineteen affiliates of an Islamic extremist group, al-Qaeda, hijacked four American airliners. Two planes were flown into the towers of the World Trade Center in New York City. A third hit the Pentagon just outside Washington, D.C. The fourth crashed in a field in Pennsylvania because the passengers on board took action.

Off to war we go against terrorism and extremism.

Some 12 years after the planes crashed or fell from the skies, another rusted piece of 9-11 airplane wreckage was uncovered in near-plain sight, wedged between two New York buildings. There it was, stuck between a mosque and an apartment building.

You might remember the story. According to one recounting, workers discovered the landing gear and the area was cordoned off for more inspection. With more time passing, it's likely that occasionally some other, to-date unfounded, piece of history will emerge.

"The twisted metal part — jammed in an 18-inch-wide, trash-laden passageway between the buildings — has cables and levers on it and is about 5 feet high, 17 inches wide and 4 feet long," according to Police Commissioner Raymond Kelly, who was quoted in the story.

Seems almost too big to miss. But there it was. Stuck. A mere block and a half away from the World Trade Center site, where a new building now stands.

Several years ago Susan Retik, left a widow with young children following the 9-11 attacks, visited my hometown to tell her story and to ask for women to work to turn tragedy into action. Covering her visit for the local newspaper, I wrote at the time, "Though she was devastated by the loss of her husband and friend, companion and confidant, she was protected and safe. She was, though, a widow at the hands of terrorists, some trained half a world away in Afghanistan, some trained by unsuspecting Americans on American soil."

Moping and grieving could not go on forever, she said. To cope, to make some sense of her life, she met with others like herself and soon founded, along with friend Patty

Quigley, Beyondthe11th.org, a foundation to counter acts of hate with acts of humanity.

Education, she said, is the key to change. Their work continues.

More than 3,000 people died in New York City and Washington, D.C., including more than 400 police officers and firefighters. Millions more lives were changed.

Some remember through reflecting. Some remember through rediscovery. Some remember by rebuilding.

How we remember is not as important as not forgetting.

What single event has marked your life?

Do you work to remember it or forget it?

What comes to your mind when you see the American flag flying?

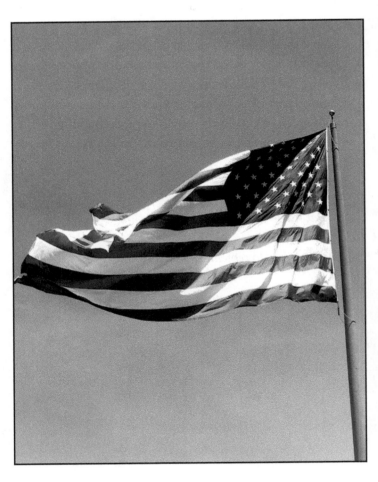

Glory Glory Glory

Dress for Success

Mr. Skinner dressed to impress. He dressed for success. He was a teacher at an elementary school who became a character, an animal a super hero, just to make the children smile. It was important to him that he helped the students, and their parents, get a good start to their days.

A good start is the first 97 percent of having a successful day.

When I met him, he was the Hulk. The day before, he had been a mouse.

There is nothing quite like getting "mean-mugged by someone's mamma in the morning," Skinner said. Skinner is tall, commanding. Everyone I saw that day was already looking up at him.

Whatever his attire, he usually went for the giggles. From a dog to a clown to just a six-foot-plus-man wearing fairy wings and carrying a wand, he made mornings fun. For everyone.

Parents anxious about their days drove away with a smile after seeing him talking to the kids with the silliest of outfits on, with no concern over how silly he actually looked.

Mr. Skinner wasn't always a teacher. He was once a kid who had a terrible school phobia. He remembered the scars. I watched this larger-than-life superhero greet the

kids as they arrived at the Scranton Elementary School. Humor changed things, made the ordinary less ordinary. Even for the casual observer.

I just couldn't stand it, going to school, he said. And so after becoming a teacher, he began a one-man crusade to cure the school-phobia blues. Just because he didn't enjoy going to school did not mean the students he worked with had to hate it, too.

He promised to give them all something to look forward to every day.

This way, they come, forget about having to wake up so early, forget about having to eat the eggs they didn't want ... oh, and he most assuredly does what he does for the parents, too.

He delivered giggles in the morning, and they all start their days with a smile.

How far out of the norm are you willing to go to help someone have a better day?

How do you set up happiness for the next guy?

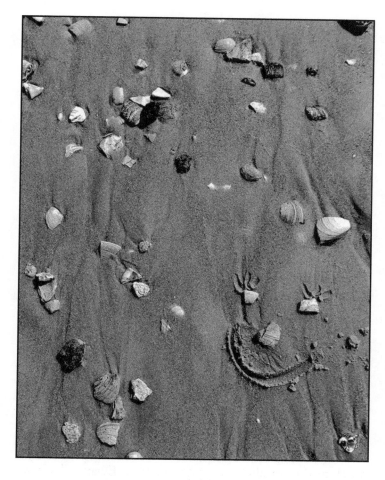

Find the lovely in the moment.

This is the day.
Make it brighter for the next soul.

New Crops

Where a house was, will soon be a field. Where a field was, there is now a house. Soybeans come from the clay of the old place; a doublewide is planted in the corn field.

I miss the activity at the old house. I didn't know the owners, but heard stories as I was growing up. They raised turkeys. It was dilapidated and needed tending when I knew it. They slept on the porch in the summer. Air conditioning was the best breeze they could get.

The old family carved out a life in the house at the edge of the field. They lived off what they grew, caught, raised, created, sold, traded or just got.

Children scampered around outdoors in overalls, barefooted, laughing and running, kicking up the dust. Children jumped off the porch. A fiddler once leaned against the porch rail.

A guitarist sat on the steps. Goats and pigs were in their pens right near the house. The mule tethered to the tree.

They were that family. The once-sacred homestead was stuck in the middle of a custody battle. Eventually, it sat abandoned, alone, then neglect, indecision, apathy, hard times, bad choices, contributed to its emptiness. Soon, it will be pushed by the dozer into a heap.

Where a house was, will soon be a field.

Where a field was, there is now a house.

I miss the corn rows; I ran among them playing hide and seek, but I am getting used to seeing the new place, hearing stories of their puppies. This new family is etching a new thing into the grass of a yard, going to work and coming home.

I see their cars in the yard, the newly-planted tree, there are closed blinds at closed windows. Boxes that held the new arrivals are stacked by the back door steps.

This is another family, growing a home where the corn once grew.

A home of hope was wheeled into the middle of the field.

For now, new crop grow.

In what ways has change come to the community in which you grew up?

How have you changed since you were fifteen?

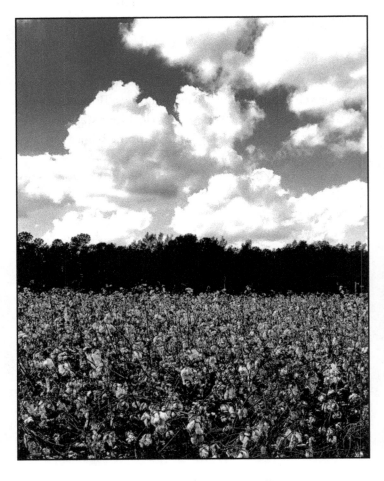

Cotton balls large and small,

come and go,
wither and grow...

I Share These Truths

My girls will attest. I speak truth-isms. The gospel, according to Dianne.

For instance, "You can learn it when you're 13, when you're 21, when you're 45 or 72, but there are just some things that are true and meant to be learned. Learn it early. It'll benefit you more."

"Ask a lazy person to do the difficult task. They always see the simple in the difficult."

"You can do better. You can always do better."

"Make sure those you love the most get to see you at your very best."

"When you see the worst in people, forgive them, right away. They will get their correction soon enough."

"My next mistake will be a new, improved and better mistake."

"We don't know where we're going, but we're on our way!"

"Life isn't fair, and then you die."

And here is something I picked up from a bumper sticker in the courthouse parking lot in Hinesville, Georgia, in the mid-1980s. I live by it. It spoke to me then, it speaks to me now:

"The probability of being caught doing something ridiculous is directly proportional to the stupidity of the act."

To that I add it is far better to let people think you a fool than to open your mouth and remove all doubt.

Just saying ...

What spoken truth-isms guide your life?

What unspoken ones guide you?

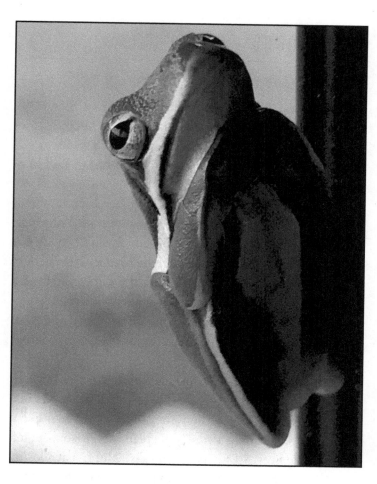

Through the looking glass ... there he is.

Back Roads

William Least Heat Moon called his journey *Blue Highways*. He took a road trip around the whole United States in the early 1980s and traveled roads which were, on his map, blue. Hence, blue highways. He set out to find himself among the people.

Sandra Griffin dreamed of riding her bicycle across America. And so she did. She wrote about what she saw, heard, felt, tasted, imagined and hoped for in "*2700 Before 70.*" She took, as often as possible, the road less traveled.

I study road atlases. While my tiny GPS offers me a piece of the pie that is my journey, I like to see the big picture, at a glance. And, while a map offers a broader view of the miles ahead, it is the atlas that binds the roads together in bundles of hope.

I do love a good back road. I'd rather travel through time at a slower pace than to whiz to my destinations in a race with everyone else. Few things slow us down like a back road in farming country in planting season. Think tractors. Big tires. Steady pace. Not fast. Not fast at all.

Behind a tractor a person can take stock of where he is, where he's going and what he's doing. There's thinking time.

My dad would wander down a road in his car or truck – the vehicle was unimportant. What was important was

the journey. Arm out the driver's window, watching the crops grow, he meandered the roads. As his pre-teen passenger and later, his driver, I was sentenced to his pace, attempting to see what he saw through his eyes. Mostly, I saw dirt and dust. He saw things growing.

Back roads grow on you. These days, I too enjoy a drive to watch the crops grow. I pass on the stories to others riding with me.

Once, when driving along on a dirt road on a particularly windy March day, my dad said "Look. They're changing farms." I had no clue. He laughed and explained the land on the left of the road was moving itself by way of the wind to become part of the field on the right of the road.

I have never forgotten that truth, nor the way he saw the wind as a worker bee, as a change agent. The wind was at work. You can't see that when you're hauling butt at 80 miles an hour on I-95. You may be creating wind, but you are not watching it create art.

Along with farmers exchanging their land, back roads let you in on secrets and allow you to see the miraculous and the mysterious, buildings tearing themselves down, people hard at work hanging on to what they have, and houses growing where tobacco once did.

Solar farms bloom where cotton blossomed. I lament what might be loss, but can't wait to see what might come next. And I can't see changes if I don't take the roads. I won't know what was and what might be.

Back roads and blue highways slow you down, to the pace where you see despair and taste hope. Communities grow at crossroads, bundling people together in like causes

and changing times. These roads bid us to make our travels slow and our memories wind proof.

Take the long way home.

The journey or the destination?

Why not both?

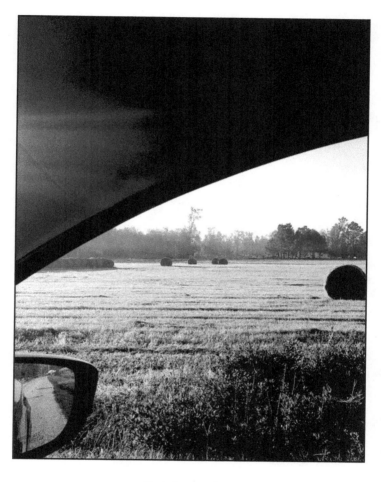

Out the window

We gather. Together we are stronger.
We gather together.

75

Competing Legacies

"A precious soul has gone home," the letter to a friend said. "We will miss her."

She lived, she cared, she taught, she loved. She was loved.

She baked breads and casseroles and shared them with the community. A large number came to pay their respects.

There was nothing she wouldn't do if it would help another. "Heaven is sweeter and the stars are brighter. She was our friend."

What should have been written is "her soul left her and thus she died. I will not miss her."

But who writes the honest letter about the dead?

She lived, she cared about herself, and she lectured. She loved?

She baked breads and casseroles and shared them in the community so she could get the credit and to keep others from helping. She crowded them out.

A large number came to see who would come to pay their respects.

There was nothing she wouldn't do if it would help herself. "Earth is sweeter and the stars are brighter. She was not my friend."

Where is she now?

What will they say when I'm gone?
Will it be the truth?

Every day we write our obituary.

What will yours say?

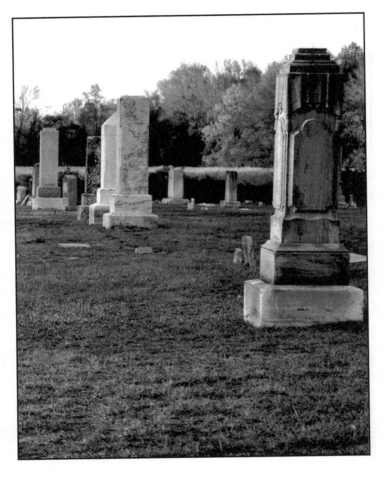

We all end the same.

Living makes the difference.

Playing Dress Up

I'm not joking when I tell you that I've learned a lot from playing dress up. And I'm not joking when I tell you I did not want to play dress up in the beginning.

Some years ago, my husband and children decided it would be a fun family hobby to join a group of American Revolutionary War Reenactors. We all had much to learn.

I was the complete reluctant reenactor. For the good of the cause, for the good of the family, I put their desires before my trepidation and entered into a tightly-knit community of people I did not know, or quite understand. Over 20 years or more, I became one of them.

Our children grew out of the hobby and I missed our weekends of "camping with a theme." A few years went by and I met a man playing dress-up on a spring day in Marion, S.C. A new ragtag group of previously unaffiliated people joined together again to become a local reenacting group. We dressed up and acted as if the year was 1780.

Reenacting. Living history, it's called. The American Revolution in the South. Reliving a history I did not live but have come to better understand. Better understand, I believe, each time I dress up to play the role of a woman living in 1780 in the colony South Carolina. I research to be better at it, to give an authentic re-creation, which isn't entirely possible, but approximately possible. I think about the eighteenth century with my twenty-first century mind.

I put on the clothes of another time period to depict, and quite possibly channel, an ancestor who lived in Colonial America. I pretend to be a person I am not to teach others about our collective history, heritage and beginnings as a nation. I read another book. I have to study to play my part well. I have become a student of the time period. I can discuss ambushes.

I don't play dress up because I didn't get to play dress-up enough when I was a youngster. I don't reenact because I like being the center of attention. I reenact as a way to teach and understand history. Every time I put on the garb of that other time, I learn something else about the strength of the people who fought in the American Revolution, about the way they lived, and what they felt was necessary and important.

I dress up and try to interpret this time in history because I believe this particular history is an important one to remember. I am a colonist in South Carolina, one of many creating something new from the backwoods.

History reenacted sometimes gives the past a new life. I have lived by a fire, during day and at night. I have not just imagined this history or viewed it and its unreal special effects on a screen.

I use my apron to carry potatoes and onions. I use my apron as a hand mitt to protect me from the heat of the fire over which I'm cooking. Until you do that, you can't really know what a chore, or joy, it was just to get a "hot" meal.

Hot water from a tap is all the more a miracle to me. I have a special affinity for flushable necessaries. I struggle with the tote and toss kind.

I know how to lift with my legs, thanks to a proper set of stays under my bodice, and how to fetch. I know why

women wore their hair up, with caps on top. Some things are best out of the way.

It has been said the rebelling folks in my neck of the woods were common people doing uncommon things. Sometimes we have to do things for those we love, things we cannot imagine ourselves doing. And then we cannot imagine ourselves not doing them.

What did you do for someone else that you now do for you?

When was the last time you did something for the good of the whole?

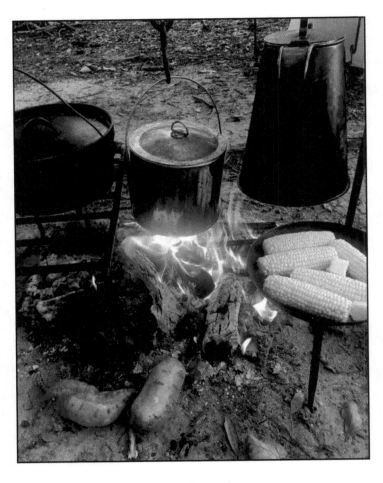

Over the fire cooking

*We are capable of doing more than we know,
and being more than we expect.*

Be Free

*Let there be music and, if you dare,
dancing with abandonment and joy.*

*Let there be humor, and if you are brave enough,
laughter, uninhibited and free.*

Do not be bound.

Where the spirit of the Lord is, there is freedom.

DPO

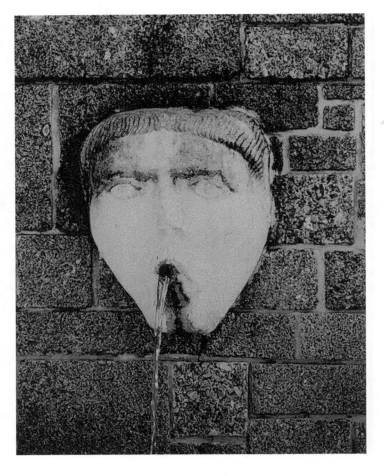

Let it go. Let it flow.

St Augustine, Florida

Unintended Consequences

Be warned of unintended consequences. They lurk. They eye us from afar. They are always there, these unintended ones, even the ones we can predict.

I smile at him, he smiles back at me. I wave at her, she considers, and then waves at me.

An object at rest remains at rest. An object at rest remains at rest unless acted upon by an outside force. An object in motion will remain in motion. An object in motion remains in motion until acted upon by an outside force.

Each action has an equal and opposite reaction. Predictable laws of nature.

I read once that we have to understand that if we invent the plane, we invent the plane crash. There was no car crash until after the creation of the car; no derailments without the train ... in particular a train in motion.

We think we're doing one thing, and then, WHAM! It appears we're actually doing another.

As best we can, we think it through. We make our choices. Then we, and likely those around us, live with the consequences of our actions. And we live with the consequences of theirs. Wise choices and good decisions: Those hedge our bets about the unintended consequences.

We jump off the highest cliff and look a little like we're flying, for a moment, they say. Then gravity.

If all I mean to do is toss a wave of politeness, and it wasn't an invitation to chat, but it is received as the request for an all-out conversation, starting with "How are you?" I need to understand that's a possible consequence to the wave.

If I mean my wave as the conversation invitation, and it is interpreted as just a wave, well … then …

Do I lie? "I'm fine." Do I avoid? "Oh. Hi." And move away quickly. Or do I engage? "Fine. How are you?"

What goes up must come down. We can expect the expected. The learned. The known. We cannot anticipate the unintended. But it's there. Lurking.

What was the "best," "worst," and funniest unintended consequence you've encountered?

When was the last time you spoke to someone you didn't know?

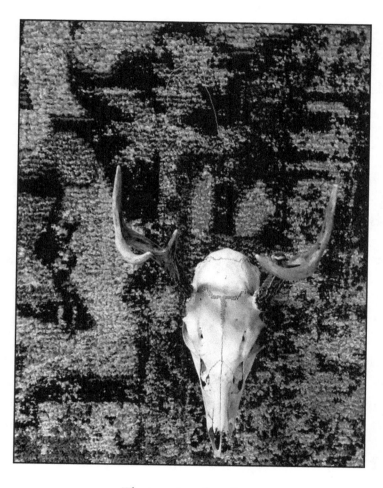

The tapestry of our lives
brings us surprises and glitches.

Answered Prayers

"I don't see why we have to tug and fight," a council member said during a council meeting I attended. I was reporting the story for the local weekly and the county's daily newspapers.

There had been an election, and a subsequent change of leadership. Some came to the swearing-in ceremony of the new leadership to witness history in the making. Some came to fuss and cause a stir.

It appeared some folks came in hopes of seeing a fight, or perhaps to just egg one on. I don't think anyone came expecting to see leadership at work.

The meeting was called to order; the Pledge of Allegiance recited. The people agreed on the words they spoke and raised a unified voice.

A prayer followed. I'd like to say it was the prayer that worked.

First the mayor, then the council members spoke. From one council member to the next, from one citizen to the next, each taking his or her lead from the other, there was agreement.

Conciliatory words. From "us and them" to "we." The wounds caused by poor leadership had a salve put over them.

Healing could begin. Scars fade in time.

Words without action are meaningless.

Leaders take leads and give leads; stretch out hands. Condemnation and animosity, accusations and rumors, are replaced by forgiveness, acceptance, cooperation. Then come the hugs.

Finally.

You have to pray; even pray through the disbelief that something can change.

"I don't see why we have to tug and fight..."

You pray for something long enough, you might not believe it when it happens.

Why do we have to tug and fight?

What do you pray and wish for, dream of?

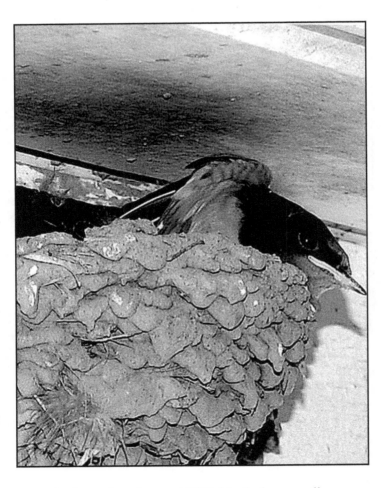

Maybe ought to have said "No" to the barn swallow.

Instead of fighting with her, I chose to share, for a season.
She raised four new swallows.
I watched.
I answered her prayers.

The Notebook Project

Ahhhh! "The Fat Lil' Notebook Project." Or "The Purging."

Since forever I've been jotting down the words spoken by other people, descriptions of things I've seen, thoughts I've had, putting into print feelings created by circumstances and situations, capturing ideas, trapping recipes, what ifs, grocery lists ... you get the picture.

At one point in time these thoughts filled volumes of little notebooks. My rants and raves. What I believed was the important stuff.

Years go by and you have to shed yourself of these little fat notebooks. You have to make way for something new. Space is precious.

As I reread these treasured gems, I realized these books contained stuff that time has made trivial – the monumental is now minute. I believed I was creating a running recording of life, and was sure I'd forget something if I didn't write it down. Now I know we remember the stuff we need to remember as well as remember stuff we have to work hard at un-remembering.

I do not need a fat book of words to remind me how tired I was of mothering and working full time and commuting to the job and doing all that you do when you go through that very busy phase of your life. I remember it, and I see it in my daughters' lives.

I survived what has come and gone and am surviving what is. I have faith they will survive, too. Through the tiny pages I discovered two lessons:

Lesson 1: The regular stuff always co-exists with the great. Hence my "You have to clean the toilet no matter where you live," or you have to work hard enough to have the money to pay someone to do it for you. But the nasty has to be dealt with. Every day.

Once upon a time, I lived in beautiful Anchorage, Alaska. I was a young, beautiful woman, newly married to a handsome U.S. Army Lieutenant, stationed 5,000 miles from home on a grand adventure. At every turn were gorgeous views of the mountains ringing Fort Richardson: the Chugach, the Alaska Range, the Kenai and Talkeetnas.

Admist all that beauty, though, someone still had to clean the house and do the dishes and wash the laundry. And clean the toilets. The mundane and the yucky stuff always coexists with beauty.

Lesson 2: That thing that irks you today will be gone eventually. Maybe not dirty toilets, but maybe the other irksome stuff, if only for a day or two.

There I was elbow deep in the midst of the poopy-diaper stage of raising children. You think you'll never do anything except change poopy diapers. But, low and behold, one day, the diapers are gone, the children

are potty-trained, and feeding themselves, and life has continued.

There is life after poopy diapers. And there is even life during the poopy-diaper stage. It's hard to know that though when you're busy holding your nose.

Is there a better way to spend today than what you have planned?

What have you endured that others around you have had to as well?

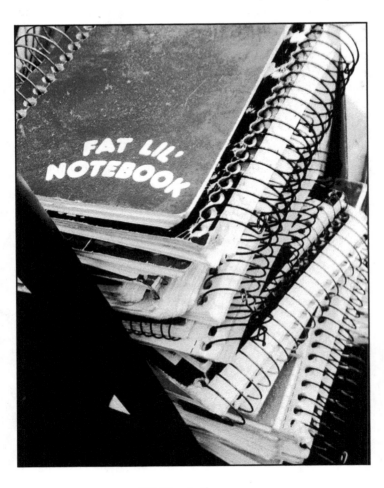

Writing is therapy.

Once written, let it go
Hanging on to your words is not therapeutic.
My tower of notebooks and memories,
Prayers, answered and forgotten are all behind me now.

Get To It!

Throw the covers back, get up. Show up.
 Get started. Smile. Walk around.
 Don't give in to stagnation.
 Call someone.
 Text your grandma and grandpa, separately.
 Jump. Dance. Keep moving.
 Meet your deadlines.
 Be thankful.
 Forgive.
 Some say life doesn't come with directions, but directions are clear to those who seek.
 Once, at the zoo, I saw the sign that said "Treetops Adventure," arrow left; "Nature's Edge Walk," arrow right. Good directions. Choose a path. Enjoy.
 Rest. Repeat.

Do you remember a time in your life when you got lost and it turned out to be a good thing?

Why do you need directions?

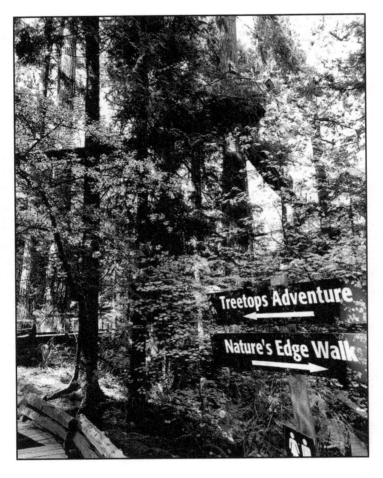

Sometimes life does come with instructions.

Riverbanks Zoo, Columbia, S.C.

Eulalee

I do not forget her.

Her angular oval face flickers on the movie screen in my mind. She's not always smiling. But she's always at peace. Sometimes she is accompanied by a random, hearty laugh. Cropped hair. Slight frame. Shoulders back. I do not know the color of her eyes, but it doesn't matter. They were keen, interested. She knew things.

She was kind, and helpful; her arms welcoming and warm. She was one of many cousins to my mother's mother. And I liked her. I liked being in her presence. I think she liked me. I love the way her name rolls off my tongue. Eulalee.

"Eulalee Evans McLeod, 92, passed away peacefully on August 17," her obituary reads. One day after my 32nd wedding anniversary, she celebrated her moving on alone. I celebrated my continued togetherness. She'd not been her usual self for a couple of years and finished her days surrounded by others in her predicament, feeble and in need of watching and care.

Born in 1920, 39 years before me, Eulalee, like a melody, sang through the years of want and desire and plenty. Her sons carry her gestures and intonations, and dance through their years in remembrance of who she is to them. She was one of Charlie and Kate's daughters, and the re-

maining half of Mr. and Mrs. John McLeod. And she cro-
cheted.

She went to church and cooked and clean and cro-
cheted some more, and sewed and worked, seemingly
tirelessly, with her hands. She read often and much. She
hand-crafted blankets and afghans and quilts, which be-
came gifts to friends of friends of friends whom she never
met, but who spoke well of her. "Mrs. McLeod gave 125
quilts to 'Quilts of Valor' and various other VA facilities."

"Selfless," the newspaper reported in its final story
about her, "a loving and dedicated wife, mother, grand-
mother, and friend who will be deeply missed by those
who knew and loved her." She was what they said she was.

"The family of Mrs. McLeod will have visitation from
noon until one o'clock p.m." The visitation, when folks
gathered and offered condolences to the family and said
their goodbyes. My memory of Eulalee finds a way to visit
me. I have a bowl that was hers. I have tea cups and sau-
cers. I am honored. We remember her.

"Memorials may be made to the Wounded Warrior
Project ..." She came of age when a world was at war. She
knew many who sacrificed so she could keep her home
and raise her children. Her family served its beloved coun-
try well.

I will not forget her. I sometimes hear her soft chuckle.
I liked her. Shoulders back. Piercing, intelligent, bright
eyes. Their color may be lost to me, but she is not.

What makes a person live on after they are gone?

Who do you miss the most?

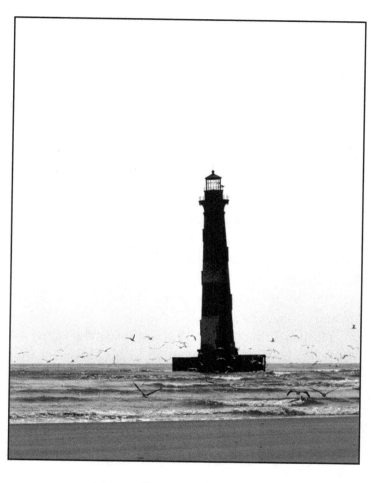

I think of her as Madame Morris

She watches, sees and guides.
Still.
They saved the Morris Island lighthouse, shored it up.
Madame thanks you.

Sipping from a Saucer

My granddaddy Jim often drank his sweet, milky coffee from the saucer that his cup sat in. And that's the way I learned to drink my coffee. Not from a mug, but from sipping from a saucer.

The art of drinking scalding coffee from a saucer is gone, I fear, but I'm glad I was among the chosen to see it performed so eloquently. Jim, with the nickname of "Sapbird" and its shorter version, "Sap," as I remember him, is not the same in anyone else's memory. This is my memory. Maybe he's more of a dream.

He died from cancer in 1981. He surely cleared six feet tall in his more youthful days when his shoulders were squared and his chest broad. His blue eyes oozed mischievousness and a ready chuckle perched at the corners of his mouth.

His overall pocket in the prehistory days and his shirt pocket in his more modern ones carried Juicy Fruit gum. Worming out of him a piece of that yellow fun-ness was one of my favorite pastimes in the 1960s.

I can still see me, cropped shoulder length brown hair with bangs at my brows, blackened bare feet, shorts and buttoned shirt standing in front of him as he sat in a rocking chair on the porch. I am reaching for the prize in the pocket.

He is catching and dropping my hands, both of us are laughing. Occasionally, he pokes a finger in my side and throws me off my game. This sap of a man was fun, and determined. This same man took needle and thread and stitched his own flesh when a tear required it.

There was once a photo of him left in a box somewhere in London, last seen by me in the 1970s, a gift to a visiting relative, that showed him barefoot, pants rolled up to his ankles. He had been fishing and was returning. His hat kissed the top of his head, barely hanging on, with his forehead and face exposed. He stood at the end of a dirt lane with his fishing tackle adorning him. A mess of fish on a string.

But the object of the photo wasn't the man, it was the snake dangling the length of him from his extended left hand. He was showing off the rattler for his company from England.

He was a trapper, raised from a long line of hunter gatherers. He set traps to capture fish, birds, and such and he and those brave or hungry enough to try his fare ate from his bounty.

Trapping is a time saver in a world where a farmer has to multi-task. Granddaddy could not often afford the luxury of sitting on a river bank, taking the time to catch one fish at a time. He strung nets and dropped cages and let bait and time take care of catching his family's food. He gathered from his nets and brought food home to the community.

His earliest days were spent felling trees and pulling stumps to make fields that would one day provide cash from king tobacco so he could buy coffee to go with his

Johnny cakes and tea to accompany his fish and home-grown tomatoes and grits.

His later days were spent watching others put in and take out crops in those fields and sending youngsters to check his traps.

I wanted him to catch salmon in an Alaskan stream. It took years to get over my sadness that he was not able to do that. I have the need to teach my grandchildren about drinking coffee from a saucer.

What is something you do because everyone around you also did it?

What is something you've passed on to someone else in your clique?

Sippin' coffee from the tea cup saucer.

Because it's cool that we can.

Hey Cuz!

We share biscuits, tomatoes, butter beans and rice. We share sweet tea and pound cake. We are family, the children of the original cousins. They are first cousins and we are the beyond. Another generation removed.

I believe these folks would have been friends of mine even if blood and kinship, hardship and plenty, hard work and plain fun, grief and joy hadn't strung us together like lights on the Christmas tree. If one goes out, we all dim.

In the beginning were the first children. And those children had children. Some died in infancy, some were forgotten. Many are still mourned. Remember when...?

One gathered like eggs acres that were then passed out to the children. A legacy of land.

Several children traded this life for the next long before anyone was ready for such a deal. Many lived to see 80. Some lived well into their 90s. One lived to more than 100 years old. She remembered when what we call a truck was called "the machine." And she drove her father and mother in it.

Grey moss hung thick from the oaks, cypress and cedars guarding their farm houses. Time dissolved most of the moss, but the "cousins" get together when they can. We are real estate agents, teachers, farmers, hunters, business people, writers, nurses, musicians. Very main stream.

Very usual and not usual at all.

The women quilted enough quilts to keep generations warm. They baked enough biscuits to fatten thousands. We still miss Aunt Myrt's creamed potato salad. The men met obligations head on, catfished and provided, taking joy in being.

We fight among ourselves, for sure, but we fight best when we fight together. We are a continual force.

The farm houses that still exist don't sit as far from the roads as they used to. These roads are paved and well-traveled. The fields are producing other crops than the older cousins knew, and few fields are the family's lifeline.

The gathering of the cousins brings laughter, tears. Who still remembers Dot's banana pudding? The songs on the porch? Cole L's hat?

The cousins come from good stock. And I'm proud to be among them.

Who are you most like in your family?

When was the last time you sought a family member out for a meet-up?

Celebrate the fireworks.

Together.
We intend to be community.

Encourage

We all need a boost every now and then. Like the time the youth group from a local church decided to be the sunshine. Do the next good thing. This group of youth was determined to brighten their corner of the world.

At school, on cars in parking lots, at church, on the windows of the local pharmacy, and elsewhere, they posted notes of encouragement.

"Love who you are!"

"Be yourself!"

"Hang in there!"

"You got this!"

The encouragement invasion. They used the "#speak life" made popular through social media and song. The singer knows the truth. Words build up. Words tear down. These kids and their leaders were working to speak words that bring life to their friends, family members, even to their frenemies.

Mind you, these were elementary and middle schoolers. They hear the not-so-kind words every day. There is teasing. There is bullying. Sometimes it's a fine line. But these kids met the challenge to dare to do the nice thing.

Coexisting with kindness. A town employee found a note on her office door that said "You are amazing!" "The note on the door ... should make us feel amazing," she said.

"We just want to inspire other people to be nicer," one youth group member said. Why would we want it any other way?

Words give life. Create a good thing this day.

What was the last kind word spoken to you?

What was the last kind word you spoke?

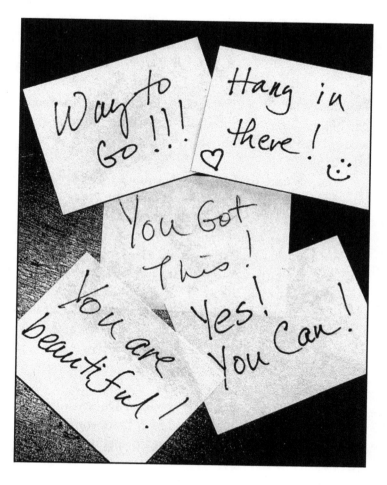

Yes, you are beautiful!

Let the unkind seek forgiveness and let us give it readily.
Let the children lead the way.

Beech Trees in Summer

For at least six generations, and maybe longer, some member of my family has occupied this land along the river where I live now. It is my turn to tend the land, to plant and reap.

It is my turn to fish, though I don't. Mercury levels, you know. But others fish and eat what the limits say you can. Granddaddy and his uncles threw nets and dangled fish traps and ate their bounty.

We had what I called a carving tree. A single-trunked, towering beech tree. And into this tree's bark, among other words, was carved the word "Creel," one of the names of one of the branches of the family that lived here. Cut into its bark was the permanent disfiguring of names and dates, 1863, 1935, 1968, 2001. This tree is down now, on its way to becoming a memory, though there are photographs commemorating its existence. It had a good run.

This will be another story to share. Does your family have downed trees along a wood line? Does your house or home have a wood line? There are downed trees in every life.

This single tree knew my family in a way I cannot. This tree came and went over a 265-year period, and the grove of trees it lived among has been coming and going for centuries, since the first tree, renewing the grove of beech trees over the years.

A grove, with other trees, might be here when I am gone. These beech trees adorn this place, standing tall and watching. They nurture, teach, guide. The beech tree has seen, is seeing and will see.

We all grow, change, live and die. Some get to nurture and provide shelter. I wish the carving tree could stand watch a little longer. I feel a little lost without it. Where it stood, occupying space among the treetops, there is a gaping hole. More sky. More sunlight. Fewer branches and shade.

We are scattered, this family that lived among the beeches. But we return, every so often to have a look see. They don't make any more land, granddaddy said. You have to hold on to it.

These beeches and me, we intend to be community.

What do you hold on to pass along to the generations after you?

What have you let go of in face of change?

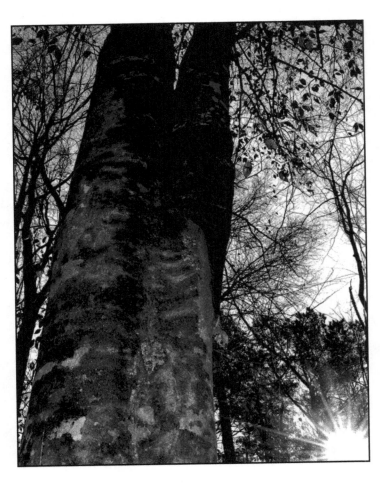

Beech Tree Lane Beech Tree at sunset

Be Ye Kind

There are golden rules and silver rules, bronze rules and tarnished ones. There are nature's laws, God's laws, man's laws, your parent's rules, and the school has rules, too. Added to those are the work place habits, accepted practices, and best procedures.

Rules tell us to stand here, in this line. Sit here. There is much we have to learn about proper behavior in a civilized society. We suppress for the good of the whole.

We wear uniforms. We conform. We shush and are shushed in libraries and churches. We put others first. We should, if nothing else, be kind.

There are proper ways to break the ridiculous rules. Seek the proper way. There are proper ways to keep the essentials. Cling for dear life to the essentials.

What would you say to the others left in your wake, if you were leaving today?

Here's what I'd say.

Keep the main thing the main thing.

Don't sweat the small stuff. Don't sweat the large stuff either.

Take a walk on the wild side.

Wake me up when it's all over.

A mighty fortress is our God.

Come together.

Be a juke box hero and just let it be.

When I die and they lay me to rest, I'm going to the place that's the best ... Jesus is just all right with me.

Take every chance to dance. It frees the suppressed soul.

Don't forget to skip.

Sing the song of life.

Choose the color of paint for the walls every chance you have. Go bold. Sometimes we don't get choices. Don't be afraid to repaint.

Memorize "Be thou my vision," "Seasons in the Sun," "Amazing Grace," and "Head Games."

Sing often "Morning Has Broken," "All you need is love," "Blessed assurance," "We can work it out," and "It is well with my soul," "Be not afraid," and "His eye is on the sparrow."

Don't leave your flag out in the rain; remember to take it down. There are rules for caring for the flag. Don't disgrace it from lack of attention. Better to not fly it than to fly it and not care for it. Oh, and, if you fly your flag at night, light it up. This is the rule you follow.

Same goes for pets. Take care of them, rain or shine, convenient or not.

Try the casserole.

Shout my redeemer liveth, and trust in the Lord with all your heart. Clean up after yourself or pay well those who clean your toilet, for the toilet always has to be cleaned.

To those who heard it, thanks for coming when I whistled.

Bring the same hope to others that sunshine rimming a dark cloud brings to those who've seen the storm.

Don't rob people of their joy. Because you can. Don't. That's a rule. Because I said so.

Remember that the blue skies are there beyond what you might be seeing. You will see the blue skies again. Be kind.

Do not let fear keep you from being brave.

The ones who came before us gave us what they had to give. Take from it what you need and leave something for the others to come.

Treat everyone equally. Don't wait for Earth Day to be kind to her. Same goes for Mother's Day, Father's Day, and your friend's birthday.

Take the cookies to the neighbor. Open the doors for others every chance you get.

Love your neighbor as yourself. Do for others as you would want them to do for you.

Forgive everyone, especially when they don't live up to your expectations. People will disappoint you. You will disappoint people. Be generous with your kind words. We are all hurt, tending to our wounds.

Let your living be about your resourcefulness, and the accumulation of resources.

Admire, not require.

If you're wondering what the will of God is in your life, stop wondering and start loving your neighbor as yourself, and you'll be doing God's will. Easy as that.

Stop straining and striving and start humming and singing. Let go.

Leave justice to the great judge and equalizer who sees, understands, and knows all.

And, above all, be ye kind.

Gathering

What do you want to say before you die?

Where do you want to be this time next year?

What are you doing today to get you there?

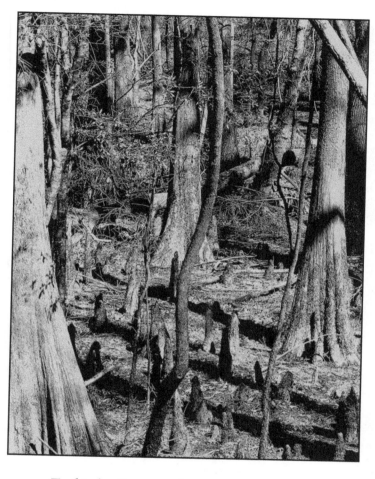

To this day the cypress knees remain a mystery.

Maybe the beech trees know the reasons for the knees.
Life has mysteries, and that's a good thing. Not everything
needs an explanation.

Cypress swamp on the Lynches River.

A Place To Be

You will know when you're home because you'll feel it.

In your bones. In your heart. In the soft matter.

In the way it smells, and in the images it provokes.

You know when you are with those who are at home with you by the way you want to sing when they are around.

Home is the story remembered that conjures up pictures for your mind to review.

Some remembrances are cold as stone; others are as melting butter.

Home is the flower that you pass in the entry to the Winn Dixie, that just right rose of a flower. Home is the chicken roasting in the deli, the bread baking in the oven, even burnt toast.

Home is that squeeze at the end of the hug from that friend who came to town just because. Because of home.

Home comes to those who work for it, to those who plow through and give more than they take.

Home is the office where you laugh at the same jokes with the same people day after day.

Home is where you are busy doing what you need to do to get to where you want to be.

Home comes from those few trusted souls along with you for the journey.

We all have a vested interest in home. Home is a keystroke, a tab away.

Home rises from tile and concrete, veneer and wood.

Home is crafted from linoleum and sheetrock, with glitter and paste.

They will know they are at home with you by the way they want to smile when you come around.

We all know when we are home.

What is "home" to you?

How do you know you are home?

Who is most at home with you?

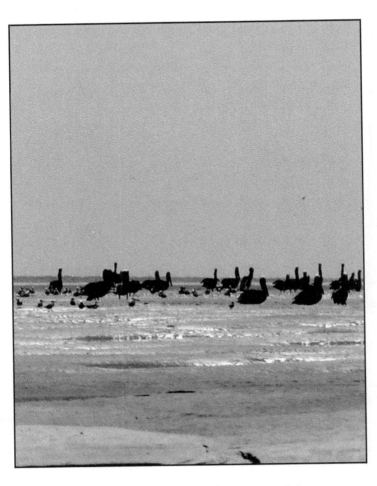

Pelican colony at home on the waves and shore

Morris Island, South Carolina

Say Yes

Granddaughter Addie is fearless, for the most part. She does fear being left out when the children are playing, and she does fear being upstaged, but what eight-year-old doesn't. For that matter, most fifty-something-year-olds fear the same.

She is one of my heroes. I love watching her play, using her imagination to solve problems and overcome any fear life might toss at her.

I was inspired by her when we got to the restaurant one Sunday. I had a "what would Addie do" moment and wanted to impress her. We were in Jacksonville, Florida, celebrating her eighth birthday. It was a terrific celebration with out-of-town friends, a Moana cake, lots of gifts and a boat ride on the St. John's River through Jacksonville. Memorable.

I credit the family psychologist John Rosemund with teaching me to say yes as often as possible to my children as their mother. That way, when I said "no," it could stand. I endevor to say yes as much as possible, to what life offers me, so when I say no, I mean it.

It was our first visit to the restaurant called Clark's Fish Camp on Julington Creek. You need to go there. Say yes to the trip. Add friends. The restaurant is set along a river that runs between and beside communities. Go there, if not by river, by car. It's the "People's Place."

The restaurant serves exotic meats and I was feeling adventurous. Among the offerings were gator, rabbit, kangaroo, ostrich, frog, turtle, llama, yak, camel, and buffalo. And if it was not on the menu, it was likely on the wall.

At one time, the restaurant billed itself as having "one of the largest privately owned collections of taxidermy in the country." And now, having been there, I know it's the largest single collection I've ever seen.

I will go back to the restaurant. Just to see the animals. They are amazing. They are interesting and worthy of study. I was impressed. There are preserved lions, tigers, monkeys, bears, giraffes, deer, bobcats, and birds. I haven't been that amazed since we left Alaska.

And then I tried the snake. Python to be exact. I shouldn't have.

In fact, many at the table did the respectable thing and declined my offering of eating the snake. In fact, it is my opinion no one should. Ever. Eat snake. I blame my choice on Addie.

If I hadn't been trying to impress an eight-year-old, I'd have stayed with the familiar, gone with something less exotic, maybe more like gator toes, which can, according to the menu, be served charred, grilled, fried and ready for dipping. Look it up on the Internet. Clark's Fish Camp.

At any rate, I've learned my lesson. No matter how bad the snake, better to have tried it and know better than to never have tried it at all.

At least I think that's what Addie would say.

What is something you've done that did not live up to the hype?

What one thing did you risk that had unexpected results?

Are risks worth the gains?

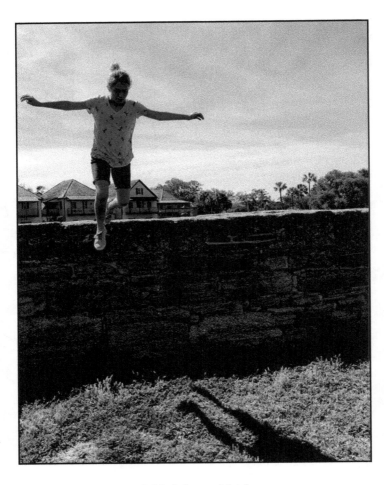

Addie's leap of faith

St. Augustine, Florida

Apothecary

Three times daily ... Take as needed.
He dawdles and waddles and slips out the door
At least three times a day, maybe more.
He's forgotten he's been there before.

The mailbox is medicine for a forgotten soul.
He watches and waits and times his steps
At least three times a day.

Take as needed ... do not crush.

Where once was offered a hope, a lulling tone,
One day comes and another's gone.
Inboxes sleep, silent is the phone.

Where is the medicine for the forgotten soul?
She watches and waits and times her steps
Morning, noon and night.

DPO

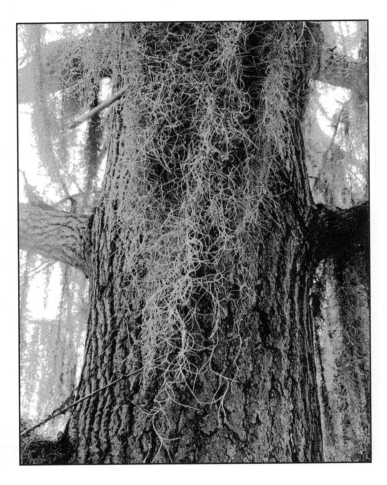

Moss, Marion, South Carolina

*The unraveling of a hem begins
with the snipping of a single, small stitch.
Who knows the beginning and end of the moss?*

Diagnoses

2017. The nurse said "Dr. B has reviewed his notes ... We found cancer in the lymph nodes. Pelvic and lower abdomen area." That bad boy cell was replicating, again.

"There is nothing in the bones." Good news among the bad news. We know it is not immediately life threatening. More good news.

"It's treatable." But did the nurse say beatable?

"Well, new treatments become available all the time. For instance your treatment was not available just a year ago. It's a good thing you've come to us."

Good news. We discuss the options.

"Once we understand the problem, we can address the issue." True that.

Good news. Bad news. It's treatable. How long?

Until it gets beyond us and isn't treatable.

Until it dries up and dies. Until.

For now, it is treatable and doable.

2010. Ethan was evaporating before our very eyes. Eyes sunk into his head. Ribs showing. His weight falling away like nothing I'd ever seen before or want to see again.

Something was terribly wrong. Just strep throat? Four days passed and he was no better. We couldn't get anyone to understand how desperately he needed a doctor. Any doctor. There in the lobby of the urgent care, we called

9-1-1. My daughter, his mother, rode with him in the ambulance to the hospital. Within 45 minutes we had the diagnosis.

Type One diabetes. Juvenile diabetes. The kid's pancreas was giving up.

"You can't take him home until everyone has given him a shot of insulin and is familiar with how to give him insulin." A pin cushion. An orange. His arms. His legs.

It is treatable.

2006. The doctor, about to deliver Alexander, said "It's a balancing act. We want to save them both."

That's my daughter? My grandchild? You're talking about my daughter? You want to save her? Save him? Get them on the raft boat, please! Now! Oh the terror that visits us.

Alexander spent many weeks touch and go in the neonatal intensive care unit of a hospital in South Dakota, daughter by his side. Son-in-law often at hers. Many times, she was alone. I had to return to life in South Carolina. I hated South Carolina for the first time in my life.

It is doable. He will be sent home on a heart monitor, but he will go home.

He will grow. He is fine.

Over and again. Over and again. There is much we do not control.

We are tiny and unusually insignificant. We put our trust in others who have more knowledge. In a God who offers love. Peace in the storm. Healing on God's terms.

Have a little faith. Faith as a mustard seed. Blind faith.

We are not as unique as we first believed. Who hasn't felt death? Who doesn't see Illness, Sickness, Disease?

It is doable.

It is treatable.

This is living.

What diagnosis do you fear most?

In what do you trust?

What glue do you use to hold it all together in the face of diagnoses

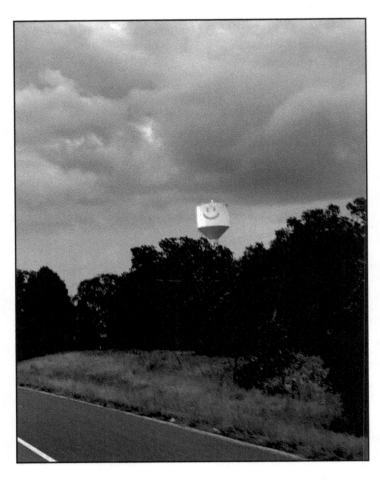

On a road in Texas …

Peaking over the trees on a stormy day.
There it is!
Hope.

Cultivating

I go outside to work in the flower beds and garden. It begins raining. Do I get a little wet or put off the cultivating? Some years ago I inherited my portion of the family farm. My intent is to go outside and urge the land to produce something.

That takes work on my part. I experiment. I plant seeds or plants, use no pesticides or herbicides. My experiment also requires God to work with me. That way, anything that God decides to water and keep the pests off will live and thrive or die, as God sees fit.

A few years ago, the nasturtiums my niece helped me with over her spring break grew wonderfully. That grand experiment was a success in a succession of failures. Some seasons are hotter, some dryer, some wetter.

My onions, peppers, tomatoes, cucumbers, and herb garden of thyme, rosemary, sage, dill, cilantro, parsley, oregano and mint were up and going well that year, too. The basil didn't make it. But the success fueled my passion to grow more.

And then the rains came. And rain caused things to come up out of the earth that I didn't want in my garden. And the rain prevented me from tending my garden. And I couldn't hoe and care for the garden, so I gave up. I grew weary in my tending.

There was a coup. The garden was not overgrown but rather it was overthrown by the weeds.

Then came the year I was introduced to potato beetles, never knowing they lurked in the soil awaiting the planting of potatoes. They just lay there, in the dirt, until potato vines spring forth. And then they set about devouring the vines. These beetles hinder growth. And I lifted leaves and picked off larvae and beetles and threw them into a bucket for disposal. It was tedious work and I wondered how badly I wanted potatoes.

One day, maybe, I might, possibly, call myself a farmer. At best, some days, I am a beginning gardener. While the plan is to grow something on the land, this year I'm growing as a farmer. I am the farmer's daughter. To claim the label for myself seems preposterous, presumptuous. Maybe in time.

I am attempting to grow things that can be eaten, to join what some call the slow food movement, one that combats the fast food movement. I am trying to keep a tradition of tilling the soil and planting the seeds and watching the earth produce food. Some years I win, some years I lose. Tending takes time.

Mine is a small, minute effort. A very slow movement. I have much to learn about what lurks beneath the soil.

I hope it's not the size of my garden but my efforts to cultivate the land that will make me worthy. I'll leave it at that. And every season is a new opportunity to plant, cultivate, till, harvest, gather.

What discovery did you make while learning to do something you hadn't done before?

What do you grow in your garden?

What efforts do you make to be less dependent on others?

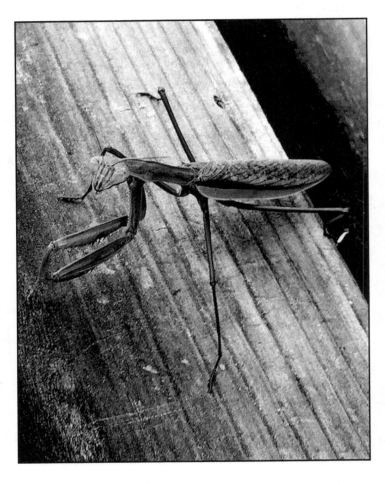

Necessary preyers

There are those that gather with us and help us out,
quite unbeknownst to us.
Keep the preying coming.

What Do You See?

I come from a long line of environmentally concerned and thrifty tin foil keepers and Ziploc® baggie savers. After all, if it's reusable, I have a moral responsibility to reuse or repurpose it.

I "hang" the washed out plastic bags, inside out, upside down over empty vases in my kitchen windowsill so they can dry and be reused. I have a line of vases on the ledge under the window over my kitchen sink just for this purpose.

Once upon a time in the not too distant past, in the house at the end of the lane, where the unusual woman lives, the baggies were drying. My then twelve-year-old niece, Anna, walked into the kitchen. She took one look at the drying bags and asked, "Aunt Dianne, why are your vases covered?"

My vases are covered?

Where? I certainly do not cover my vases.

Point of view. That place from which I looked out on the world shaded and colored everything I saw. My intentions clouded my vision.

When I turned and looked at the window I saw what I always saw, washed out baggies drying.

With her words in my ears, as if a veil had been lifted, I began to see what she saw: My vases were covered.

Nothing had changed. It was certainly true that my drying baggies were covering my vases. I only saw what I wanted to see – the drying baggies – not the covered vases. Perspective.

Anna helped me see my "usual" in a different way. My routine baggy-drying was to her the covering of the vases. I gained a new point of view.

In that moment I realized two people look at exactly the same thing and interpret it from their frame of reference. Covered vases? Baggies drying? Yes, to both.

We are in this thing together. She needs my explanations and I need her fresh eyes.

When have you looked at an object differently than someone else?

When was the last time you really saw something from another's perspective?

What do you use differently from its intended purpose?

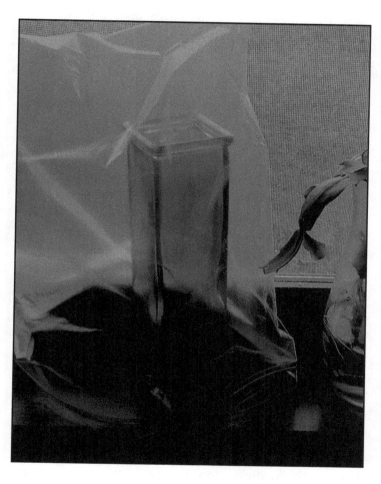

Covered vase on the window sill

A Time to Sleep

I've used the full moon as a night light when camping with friends. If you camp, you know what I mean. You understand. You may also understand that these two things are most difficult to do: stay awake when you're really tired (the kind where you know you're going to doze if you sit still long enough because you feel the heaviness of your head and the weakness of your neck), and go to sleep when your mind is otherwise occupied (when you can't turn the hamster wheel off until it says it's done rotating).

Light from the untethered moon, and the tethered lights dangling along the street, make for sleepless nights for some. For others, nothing can keep them from getting their proper shut-eye.

Nature's full moon is a call for a visit with the larger-than-you. A reflection of what has moved on. The tethered moons, the streetlamps, illuminate what otherwise would be hidden.

Maybe an hour of wakefulness and a little prayer could have saved Peter a morning of turmoil. But, like many of us, he was too tired to stay awake and watch. Too tired to linger with the divine, too tired to do that which he was asked to do. He had walked more than his 10,000 steps that day.

He misunderstood. He thought he could take a vacation from vigilance. He chose sleep. I want to know, *if* he

had stayed awake, would his day have gone differently? I digress.

Can you sleep when there is light outside during the night?

Another natural night light comes from little winged beetles that dance with their intermittent, blinking flashes at the edge of the woods during the nights of late spring, summer, and when we're lucky, early fall. Lightning bugs, we call them. Fireflies. Divine lights that fly, a distant relative of the crawling glow worm.

They are seen in the mountains, by the sea and nearly everywhere in between. They take in oxygen, mix it with a little luciferin, throw themselves a party, and produce an unheated torch that glows from their tail. This flitting luminary is awake at night, napping during the day. But, again, I digress.

Can you sleep when there is light outside during the day?

We have land-crawling critters, snails, which set no speed records with their pace of about 50 yards an hour. That's 150 feet. About half a football field. In an hour. Kin to slugs, those snails without shells, they leave ooey-gooey trails marking their paths.

This slithering mollusk is also quite active at night, and often on damp, foggy days. It sleeps in snatches and when it is awake, it is awake for hours and hours and hours.

Rest, glow and go.

Nap, rise, and shine.

There is a time to sleep and a time to be awake. Burn and glow. You can always sleep later. Maybe.

What does the saying "burning daylight" mean to you?

When should you sleep and to what should you be more awake?

Night flight in moonlight
Sleep tight

The Starfish

The starfish washed up on the beach at Emerald Isle, my first trip there along the Atlantic. It landed in a row with some acquaintances.

I came along, I'm sure, shortly after it came to rest on shore. It was before the sun was completely awake. I was jogging, as is my habit when given the opportunity (when I actually take the opportunity).

There were others out, too, watching the sunrise and scoping out the gifts left by the sea along the beach. You know who you are. Scavengers. Hunters. Lookers. Seekers.

I almost missed it. I jogged past the starfish. And yet, the shadow and thought of something different, something special on the sand, caught my eye. Perhaps it winked at me.

I hesitated, slowed, turned and stared. It was my unexpected gift. I picked it up. My plan was to move it out to the water's edge. But I couldn't leave it there. I tried to put it down. I couldn't.

I wanted it.

I routinely collect sea weed and seashells from trips to the sea. It is a bit of an obsession. Shells are on my window sills. Shells are found on the book shelves. Shells are in baskets, in saucers, on display. My preferred home decorating style: collected eclectic.

I'm in recovery. These days, I limit my pillaging. I leave the treasures for others. I share the gifts I've been given. I capture treasures with a photo. But I had never, and have not since, found a starfish.

Sand dollars? By the dozens.

Lettered olives? But of course.

Tiny seahorse? Yes.

Starfish? No. Never. Just this one.

There is something uniquely satisfying in finding the something you were not actively looking for but have always wanted to find.

It takes the right place, the right time. Stars aligned. Ecstasy. The found gift is a treasure.

What does it take to recognize the gift that is present?

What makes something a gift?

What do you collect?

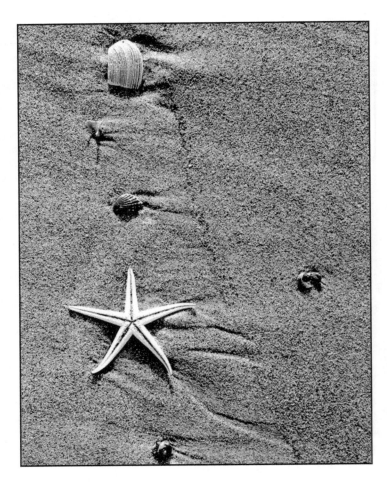

The starfish

God Loves Us

I know God is and loves me because, first, God invented English muffins – and, second, they were miraculously delivered to those of us who worked at the college together, free. No charge. At this point in my life I'm able to buy English muffins from among the offerings in most stores with a bread aisle. But at one point in my life English muffins were a sheer luxury.

I could purchase a long loaf of fortified wheat bread for all the family to eat, but specialty breads – such as English muffins? No. They were not a necessity. That was my reality.

These muffins were wasted on the others in my family, as I was the lone lover of that particular texture and taste. And at that point in time, there was little room for wants. We were into filling needs.

As it was, though, I worked in a place where every so often bread was delivered – gloriously wonderful free bread for the taking. Loaves were placed in the break room. Just because. In someone's world, the bread was outdated. In ours? Proof that the good Lord above was my portion; that God provided.

Instead of going around spouting "It's not fair! I don't have enough money to buy English muffins!", I put them

out of my mind and nearly forgot they existed. Until then, one day, there they were.

On the table. Provided for me, for us. The needy. The lacking. The ones who were longing.

Dependency is not a bad place to be when God knows the wants and the needs, even, especially, the English muffin kind of need. The Lord in Lamentations splurged on us when we couldn't.

He loved us and I understood that, because there were English muffins with raisins and cinnamon and they were given to me freely. Maybe that's why those English muffins tasted so good. It wasn't just the sweetness of the cinnamon and the savory raisins filled with juiciness. It was because they were provided for me. They made me feel loved, cared for. Love. Love is a free English muffin.

God-given bread is always best. The muffins were a blessing to us. A gift. They would have spoiled and gone to waste. Instead, we were the ones spoiled.

When pinching pennies, you can never beat the price of a gift. God knows the desires of our hearts. All of them. Even the English muffin ones.

When has the universe sent something back to you?

What shows love to you?

How do you show love?

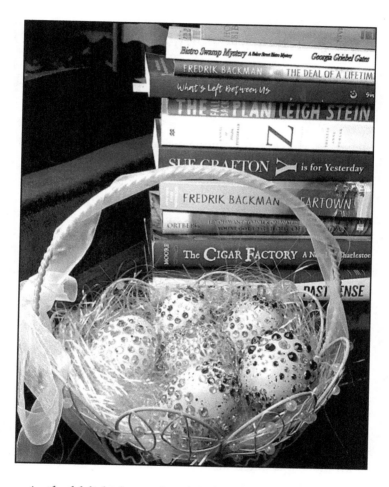

A gift of delight from a friend decorates our lives with love.

Top of the Raindrop

To see the top of a rain drop you have to change your perspective. You cannot look up at rain and see what you need to see. When it's raining, we are beneath the clouds, and we dare not look up to see the drops of water falling on us.

Heads down, we avoid the clumps of drops. After all, sometimes rain falls so quickly and so hard, it seems to be throwing itself at us. However, should you get a chance to be on, say, the twelfth floor of a hotel with an exterior breezeway, when steady raindrops are plopping their way like little soldiers past each floor to the ground, risk the rain.

Venture a peek over the side of the breezeway rail.

It takes courage, if you're afraid of heights, to lean over that rail. It takes curiosity that trumps fear to see the top of a raindrop.

A rainy vacation can easily spoil an attitude, if not an adventure. On this particular occasion the continuous rain seemed determined to vacation at the beach right along with me. I was determined to not let it keep me from enjoying myself. As Longfellow said, the best thing one can do when it is raining is to let it rain.

I looked over the breezeway rail to watch the rain land in a flower bed. My eyes focused, strangely enough, on the top of a raindrop.

And then another. And another.

They are rounded, not flat, and they glisten. Glossy fairy dust. I was captivated.

I haven't seen the top of another raindrop. When given the opportunity, I like to think I'd be willing to venture another peek over the rail of an outdoor balcony on a rainy day.

What a wonder to see something mundane from a new perspective.

What could you have done differently?

Does fear keep you from seeing beyond the mundane?

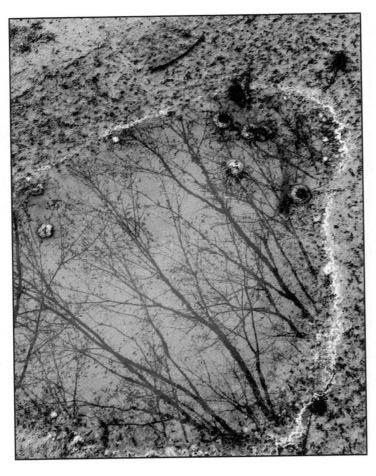

Trees reflected in a puddle, and bound by pollen.

Looking down at the treetops.

Didn't See It Coming

I missed celebrating one particular New Year with my husband because he was locked in an emergency response center awaiting the inevitable, or the probable, or the maybe. The world was about to begin dating things beginning with a "20" rather than a "19."

He was needed on hand, as his job required him to be ready, just in case the world ended.

Seems like only yesterday the whole world was dreading the turn of Y2K. The year 2000 was expected to cause a computer software implosion. Hours upon hours of work ensued. Crisis averted? Hoax? Conspiracy? Much ado about nothing for some, a lot of work to comply with extra digits in data bases for many.

Now, years later, we march on into the future, another year behind us. We don't know what this year will hold. We all move forward into the unknown, taking our updated computers and smart phones and tablets and watches and implants with us. We move forward or we get stepped on.

I started this year by having the three grands as house guests. They are anything but guests. They are invaders, taking over every nook and cranny of the house. This year was quieter than many in the past. They are older and their toys are newer.

There was this one time, though, when this was the New Year's Eve entertainment: Stomp! Stomp! Stomp! EYEYEY! The sound of a herd of elephants coming off the stairs and into the hallway – followed by more EYEYE!

To which came, "Addie, don't chase the boys around the room with the Barbie!"

Then, "Boys! Quit running from Addie and the Barbie … they aren't going to hurt you!"

"Get that out of your nose! Now!"

"No! Don't put it in your mouth! You don't take it out of one place to put it in another. Well you do, but the other place is the trash can!"

Sounds of a retreating herd going, more slowly, up the stairs.

They are inquisitive, argumentative, quick-witted explorers and informants in the presence of a prima donna. They are the future. Watching children grow up is the second best way to see the effects of time. (Looking in the mirror is the first.)

The one day, one week, one month, one year turns into another. Time marches on.

Births, deaths, weddings, divorces, graduations, beginnings, endings and so on, just as there has been before … the continuity of life.

Some things will change. Some things will remain the same. To be sure, it is the things we want to stay the same that will change the most, like little people growing up. Too soon.

Amongst the unknowns for this year are a few knowns. We will make attempts to get and stay fit, eat healthier, get out of debt, or spend more wisely and save more. We will

endeavor to spend more time with people we love and less with the people we don't.

We will try to quit smoking, drinking, partaking in a vice. This is the year we will become organized.

Yep. Just seems like yesterday the whole world was dreading the turn of Y2K. What we so dreaded did not come to pass. But we were prepared for the worst.

The years since 2000 brought us much to fear. We just didn't see it coming.

What have you prepared for that has not come to pass?

What fears did you have coming into this year?

Could he see the Revolution before it arrived at his doorsteps?

He acted and is remembered.

Live Life Loosely

Somewhere along the way I heard the story of the jar and the fist, and about living life loosely. I have tried to employ the lesson of the jar and the fist ever since.

To catch a monkey, hunters placed food in a jar, the story goes, a jar with an opening slightly larger than a monkey's hand. Maybe it's a banana slice or some nut or such a treat. Along comes the monkey. It reaches into the jar with its open hand, and grabs the food.

Holding onto the food means making a fist. What a predicament. If the monkey lets go of the food, he cannot eat it. If he continues to hold it, he cannot have it. And so the monkey is caught.

Letting go is life. Holding tight is struggle.

Another version of the story is there is a ten dollar bill in a wide-mouthed mason jar. A child was told to reach in and take it out. Despite its best efforts, it could not. However, turn the jar upside down and the money falls out, no grabbing or clinching involved.

The money was the child's as long as it did not cling to the money too tightly. The child had to let go to receive it. Grabbing and holding on did not deliver the desired result.

Let's imagine the jar filled with 100 dollar bills. To the rim. Even if I could wrangle my fist and wrist back out the

jar's opening, I probably could not grab all the money in the jar in one take. Some would be left behind.

Turn that jar on its head, though, and it's all mine. The gift comes to me.

For best results the monkey and the child have to set free whatever is inside their jars. Let it go. Live life loosely. It'll come to you if you don't grab for it.

Why do we hold on to things we need to let go of?

Why do we let go of things we need to hold on to?

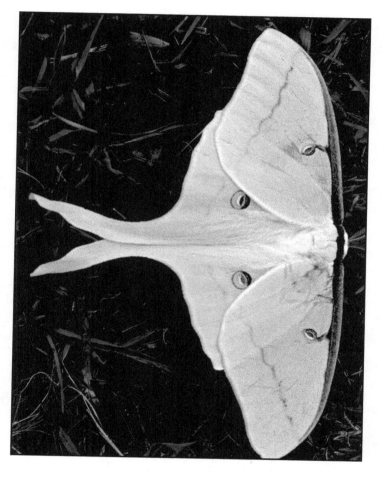

The eyes have it.

See what might be.
Be seen for what you are.

157

A NASCAR Education

I am not the biggest NASCAR fan, but I'm a fan. There are certainly more people who have gone to more races, who are more involved in the off-season drama, and who have more memorabilia in their homes.

But I plan most weekends around the races; I just watch them from the comfort of a recliner. Neither sun, nor rain, nor cold can keep me from my seat in front of the television. And if it's a weekend when I'm traveling up or down I-95, well I know which stations carry the race on the radio. I can visualize the race, thanks to the announcers' words.

But let's face it. Not all sports announcers are created equal. Some paint prettier pictures than others.

A person can get a fairly good education listening to NASCAR announcers, on the radio or TV. For instance, drivers have to "keep up their momentum." If drivers lose momentum, they start appearing to go backwards, and that's not the way to win the race. You have to be smarter, faster, willing to take a little more risk to move to the front.

Drivers have to "maximize grip." Without grip, a car's forward momentum is lessened and, well, they just slip on back, or so it seems, as slower cars get passed by others with better forward momentum. To win the race you move forward first, in front of the rest of the racing cars.

Drivers have to "manage the slide." Drivers have to have "clean air." Dirty air won't do. Drivers have to find the right "groove" of a racetrack.

My NASCAR education has helped me through many "tight turns." I downshift during adversity, catch a quarter panel of the nearest problem, and draft as best I can to a new position on the race track of life.

He's "got to have a strategy and a front bumper and be willing to use them both," a NASCAR announcer once said. And I can't remember now if it was the announcer or the race car driver who said "I'm like a box of cereal, I'm settling ... "

Once, hand to God, the announcer of a race at Talladega said "He had done what he needed to do. He had slowed down. He had stayed out of the way, but he couldn't drive the other peoples' cars, too."

I can't remember the winner of that race, but I know this was in all likelihood about a wreck. Likely one Jimmy Johnson or Dale Earnhardt Jr. was involved in. With digital video recording (DVR) I could play that expression over and over. Loving it more each time I heard it.

I don't remember the race, but I remember the announcer's words. "He had done what he needed to do ... but he couldn't drive the other people's cars, too."

I totally get it! Story of my life! I do and do and do, and then the wreck happens. I get it! I do my part, and I'm going to need everyone else to do their parts, too.

My NASCAR education has taught me to drive my car well, has helped me to find my groove and has shown me its best to stay in my lane. Mostly, even after I have done everything else I believe I can do, I cannot, under any cir-

cumstance, drive another person's car. That is their task. Their one thing. Not mine.

I am so looking forward to seeing what this race season can teach me.

Which sport is your favorite?

What has playing a sport or watching a sport taught you about life?

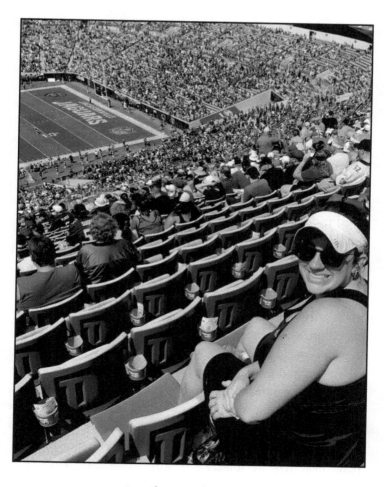

A gathering of fanatics.

A grouping of enthusiasts.
On any given day, somewhere, we get together to play,
to watch, to cheer them on.

Motivation

Be the sunshine on the cloudy day. Be the smile in the elevator. Be sincere in a world of insincerity. How do you know tomorrow will be better? Plant flowers today.

Somewhere along the way I captured the idea that I am responsible for being that which I think is needed. I need motivation. Be the motivation. I need a hug, be the hug. And so on. And yet, we're in this thing together. So I looked to the left and found my motivation.

It started with the man on the treadmill next to me at the gym in Lake City. I don't know him. But he embodies motivation, determination and pace, and the fact that we get to choose our dispositions.

The world craps on us, often. Some weeks, it feels like we're crapped on each hour of every day. There is always something seeking to steal our joy. Well from hence forth, the world can't have my joy and it can keep its crap!

I get to choose my disposition. And just as I am affected by others' frowns and furrowed brows, I make the case that they may be affected by my smile. My wide-eyed wonder.

The lean machine on the treadmill next to me several mornings in a row became my fitness muse, and in so doing, my attitude adjustment.

Oh, if only I could tread like he does, focused, steadfast, resolute. He is there when I arrive and there when I

leave. I am enthused when I walk in and he is there. My steps get quicker. I position myself beside him not to compete with him. God no! No way.

He is in *his* zone, steady charging ahead at *his* pace, rehearsing *his* race. Eyes forward.

The first time I climbed aboard the treadmill to his right, I admit, I was intimidated. He is a serious runner, seriously staying trained for the next race. I train, run a race and devolve into a couch potato to have to start training again.

I trod alongside him and learned that my pace is better with him than when I tread alone.

My gaze steadies, my desire to complete the day's workout becomes more purposeful. His being affects my fitness. I am out-classed, but I step up my game when he is near. He makes me better.

His gait is rapid fire. I plod.

His walk is long-legged and fast. I keep my pace.

His walk is faster than my run. His "steady-stay-the-course 'tude" rolls off him in his beads of sweat. I step it up. I can do this.

I try to glance at the data on his screen. Keep your eyes on your mat, I remind myself. I don't compete and compare with others. I do my best me.

I smile because he is all in. I am keeping my pace. I am still going because he keeps going. And then I'm done. I've finished my run.

He motivates me to go a little farther, a little faster, so I do.

Someone may be watching me and going a little farther, a little faster because I continue.

Gathering

I smile.
I am the sunshine.

Where do you get your motivation?

Why is a smile important?

Why is a yawn contagious?

Run the race well.

Or walk it, or jog it.
We are doing this.
Everyday.
Yes we can.

Tracks and Scat

At the back of the field, at the edge of the woods is a place where the wild turkeys tip toe. I know because on my walks I often see their prints.

This looking down when I walk leads me to ponder a myriad of tracks, and animal poop. Each animal leaves a hoof, foot or hand print in the sandy dirt. Often they leave a drop of something more special for studying.

I've become somewhat of a scat aficionado. The scat of a coyote, I'm sad to say, is often threaded with what appears on this side of that process as fur. This fur of a sort, post digestive process, distinguishes the coyote's poo from that of other canines.

I know when the coyotes are near because the squirrel, rabbit and feral cat population go down. When I spot rabbits playing along the sides of the wood line and road, I know the coyotes have moved on.

Raccoon poop looks like smaller dog turds, but has berries in it. And, just so you know, raccoon poop carries diseases, so don't mess with it.

Deer poop and rabbit poop are both pellet-shaped, but rabbit poop is bigger and there are usually more of the deer pellets in one location. You may not think you need this information, but one day, you'll wow your friends with your knowledge.

Bear poop is a large mound, and often has twigs, berries and even a leaf or two in it. Though bears will eat other things, that was the scat I saw in the swamp along the Lynches.

Moose turds are larger pellets, and if you live in Alaska or some other place farther north than South Carolina, where the moose roam, they are often shellacked and given as gifts.

One last scat story. At Christmas one year a friend gave us the gift of fossilized scat. He could not have known how thrilled I would be! The dung of an ancient crawling critter. It felt a little like soapstone. A little chalky. Just thinking of it makes me want to go wash my hands.

The deer dance down the drive to my house. I go out in the morning, leaving a few tracks of my own, and check to see who they danced with the night before.

What tracks are you following?

Where do these tracks take you?

What tracks do you leave behind?

Tracks and scat.

They are found here and there and leave us with questions.
Where did they go?
When will they be back?

Leave the Mess

A fellow employee at a Bible college and seminary where I worked made a remark during a devotional talk that led to a discussion. I continue to hear his words in my head every so often, complete with his British accent, "Some trash is better left on the floor."

I jotted the remark down to remember it, and though I forgot where the jotted word landed, I have not forgotten.

Though the complete context for those words, as he intended, eludes me, I love the wisdom behind them. See, I'm an ardent three-second rule fan, only for me, I have three seconds. You can take five seconds, if you want. I'll take three.

You know the thought: if you drop it and want to eat it and it's on the floor for fewer than three (five) seconds, you have the cosmos' permission to pick it up, brush it off and eat it anyway. Any germ contaminating said dropped food item is null, void and wholly rendered unable to spread disease.

Live by the three-second rule as I might, I totally agree that some trash is better left on the floor. Not all dropped foods need to be recovered. Not all things discarded need to be retrieved. Not all trash is really trash, but sometimes you just have to let things be.

Let's say I've learned that by spitting out some of those three-second rule retrievals. I know you know what I mean. We are co-conspirators.

For folks like me, who can't stand a crooked picture on a waiting room wall, and who once upon a time cleaned up a third-grade classroom during a parent-teacher conference because to wait in that mess was more than difficult, I know that some messes are not for us to clean up.

I picked up paper and pencils off the floor and cleaned out desks of crumpled papers while the teacher was saying, "We clean the classroom on Fridays."

Leaving things askew is Difficult (capital D necessary). Learn it now or learn it later, but learn it you will. Sometimes it's best to leave the mess.

We don't have to fix everything, you and I, us "fixers."

When wondering whether or not to pick up the trash, clean up the mess, consider it a bad habit.

You let bad habits go. Leave the trash be. Leave it beneath you. Behind you. The mess gets along without us and Friday is coming. We will be better off for having left it.

Besides, scientifically speaking, the three or five second rule is a myth. The idea that food can be snatched from the floor before germs can attach themselves is not a valid one. The dropped food carries with it, even as it is falling to the floor, a certain number of germs.

New rule: if you can't catch it before it hits the floor, let it go.

What are we wasting our time trying to fix?

What can we do instead of trying to fix this thing?

What can we let go of?

Washed up reeds.

Let them be.

Call Me When You Get Home

Call me when you get there.
It's what we say.
These people seem to think
they need to know where I am, and when I get there.

"We have arrived, in this place and space,"
as if that means we cannot leave again.

Arrival is another starting point.
Coming is another going.
Call me when you get there, I say to them.

They know I need to believe they are safe and home.

DPO

The Carving Tree

About the Author

Born in Lake City, South Carolina, Dianne Poston Owens is a self-proclaimed philosopher, poet and wannabe farmer. She and her husband Dusty live with the other wildlife in the Hannah community of her home state. She writes, tinkers, creates, communicates, and works to make things happen. She doesn't like snakes.

The couple has two wonderfully accomplished daughters, each married to a man that puts up nicely with the family shenanigans. The couple also lays claim to all the good parts of the three amazing souls they are blessed to have embodied as grandchildren. She is a member of the National Society Daughters of the American Revolution and the SC Press Association.

She reads and writes a little every day, living on her patch of land along the Lynches River, which has belonged to her family, as long as they paid their taxes each year, since about 1825. She goes to church, and pays her taxes even if it kills her independent soul.

After graduating from the University of Alaska, Anchorage, Dianne became a newspaper journalist in Georgia and South Carolina. She freelances for various newspapers and magazines while creating short fiction and nonfiction pieces. Some of her work is online, such as her flash fiction piece, "Crossing the River" about Raeford, North Carolina, at easystreetmag.com.

She has won awards for her articles, which have appeared in newspapers over the years, and once took second place in a contest for humor column writing. While thankful for not being third funniest, she is still getting over the sting of being second-most humorous among weekly newspapers columnists in the state. She is a former region editor of The Morning News in Florence, South Carolina, and editor of The Lake City News & Post, The Marion Star & Mullins Enterprise and The Weekly Observer, weekly newspapers in the Pee Dee area of South Carolina.

Follow her on Twitter @ dianneinhannah

Send her an e-mail: dianne@dianneinhannah.com

Visit her website @ www.dianneinhannah.com